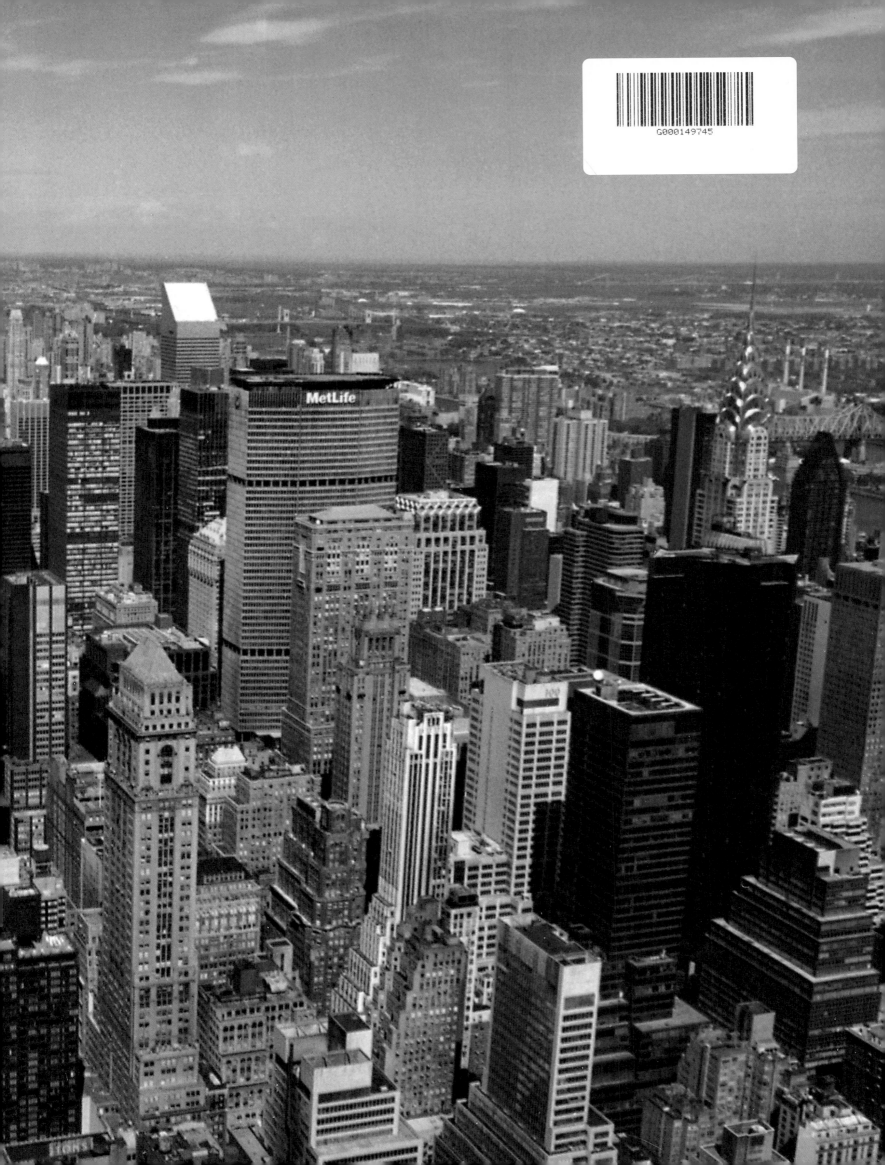

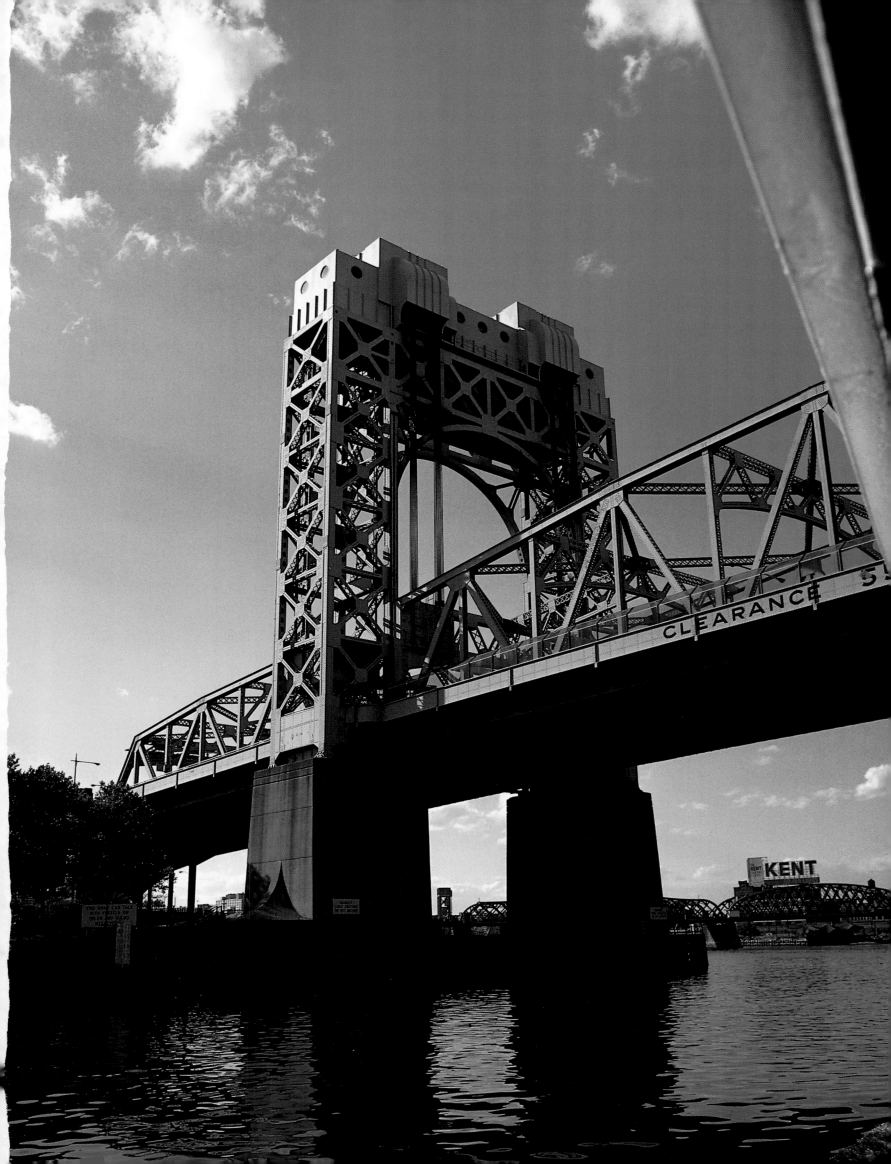

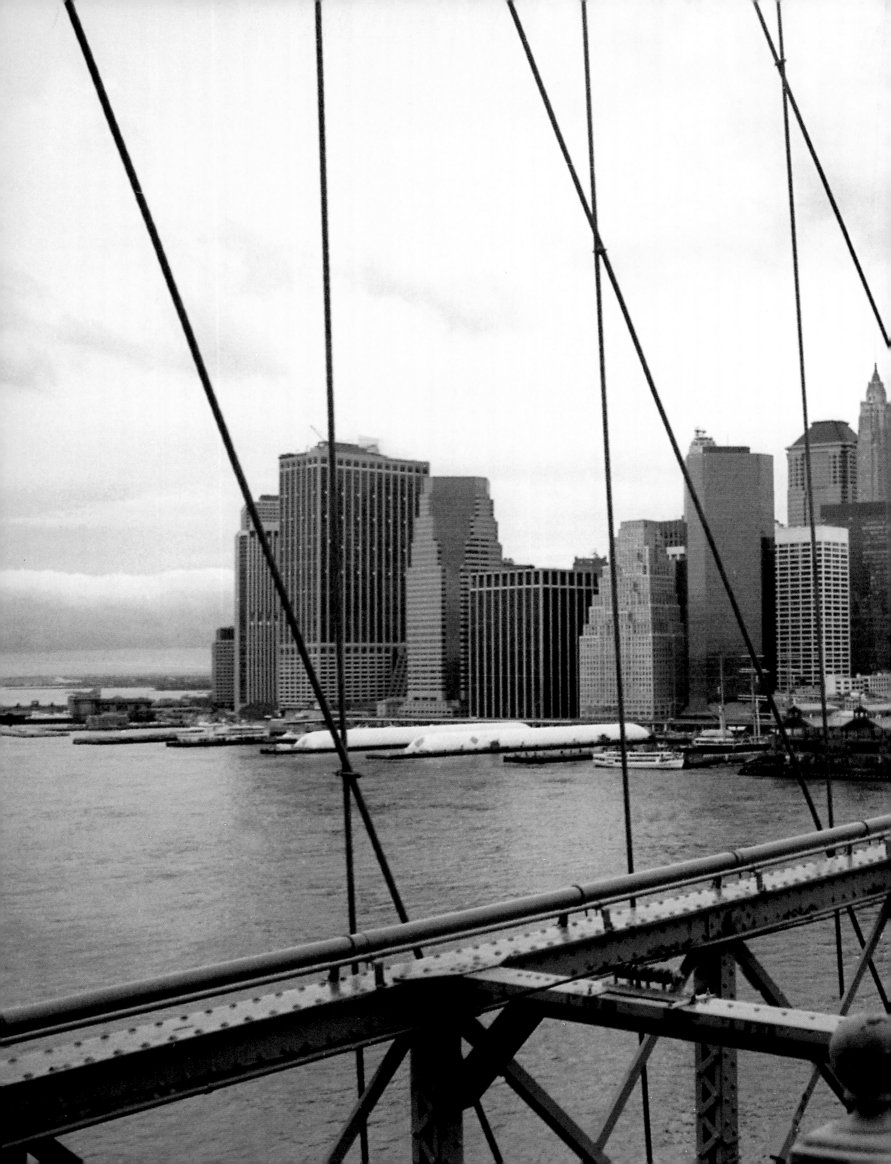

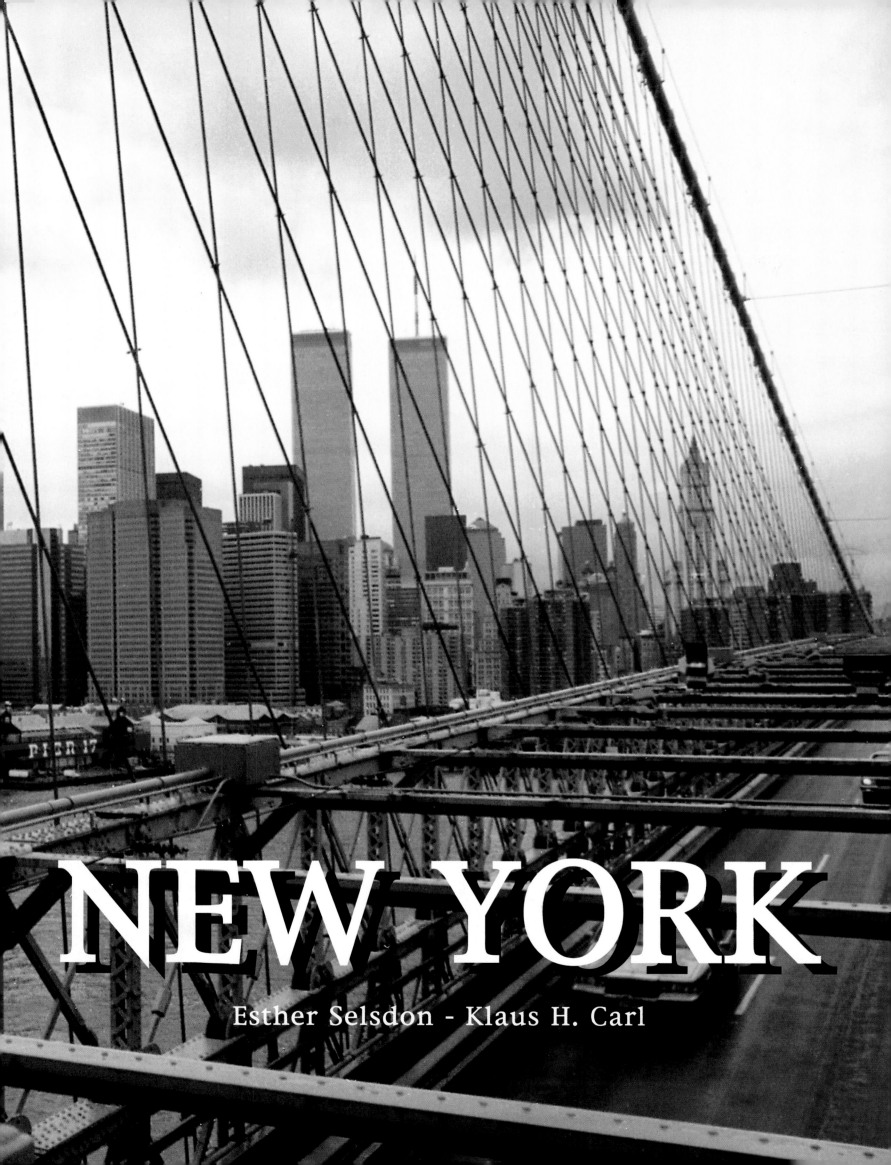

NEW YORK

Esther Selsdon - Klaus H. Carl

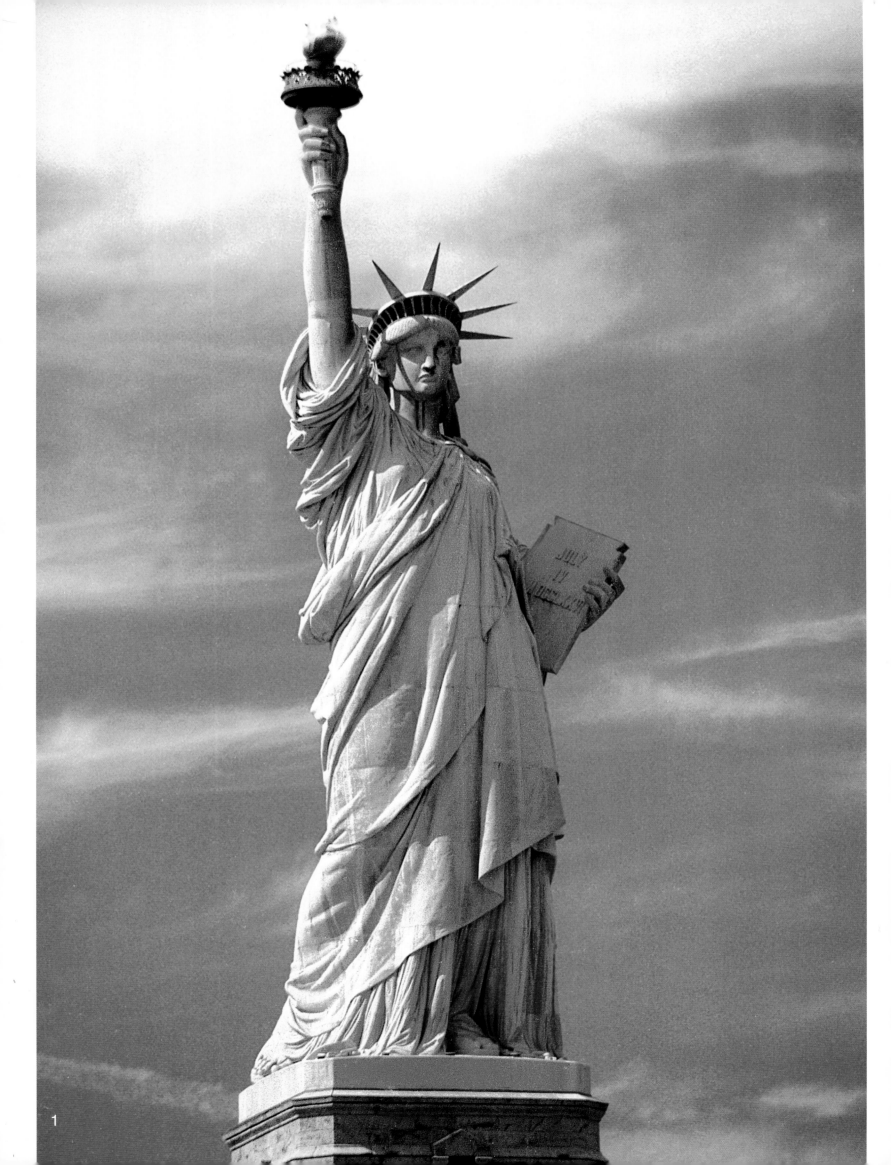

1

History

Mannahatta was the name given to the thirteen-mile long island by its original inhabitants, the Algonquin Indians, who made themselves at home on its flat salt marshes and fertile plains until Giovanni da Verrazano, a Florentine searching for the North-West passage to China, became the first European to set eyes on the bay in 1524. Despite the fact that he was greeted enthusiastically by the local Indian tribes, he was not seduced into setting up home there and it was not until 1609 that the next European arrived. The intentions of Henry Hudson, a man employed by the Dutch East India Company to exploit all the potential of the local fur trade, were entirely commercial and his interest in the natives was minimal. By 1626 there were three hundred Europeans living on the tip of the island in a small encampment called New Amsterdam which the Dutch, having generously handed over a few European blankets, now considered that they owned. The natives were not so sure. The now renamed Dutch West India Company sent in Peter Stuyvesant, an experienced colonist, to sort matters out. This orderly but rigid man had an all-purpose, defensive oak fence constructed along a ditch that soon became known as Wall Street. The flimsy thirteen-foot planks were immediately stolen for firewood so the fortifications were useless, but he was not discouraged and set up trading posts as well as the first municipal assembly. He was, however, intolerant and unyielding and, by 1664, the locals had had enough. When Captain Richard Nicolls and his crew turned up from England, they were greeted as true liberators and the Dutch colony was instantly renamed after their king's brother, the Duke of York.

The British finally surrendered New York to the locals in 1783 and, in 1789, George Washington took the oath of office in the Old Federal Hall and became the first President of the United States of America with the city simultaneously (though not for long) becoming the nation's first capital.

Statue of Liberty (1)
Clown (2)

Manhattan was barely affected by the Civil War and, as the first great waves of immigration washed into the city after the Irish potato famine of 1843 and the disintegration of the Russian empire in the 1880s, its harbour prospered as the most convenient port of entry from the Old World.

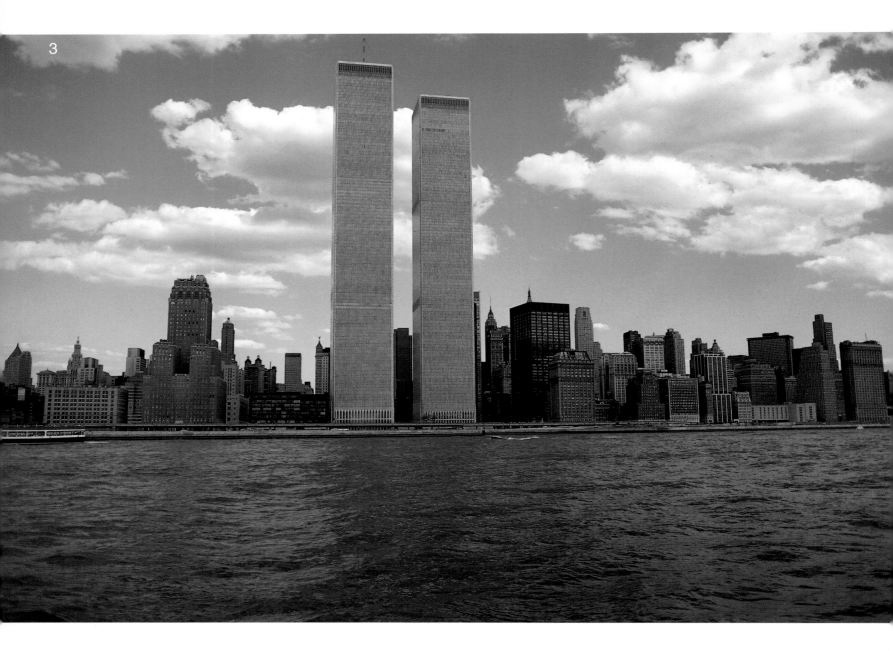

From 1855 to 1890 the immigration centre at Castle Clinton in Battery Park processed eight million arrivals and, by 1892, the Ellis Island Center, a purpose-built 'reception area', had handled twice that number. New York's reputation as the world's arrival hall was born.

By 1910 there were over 1.5 million Jews in New York City and a quarter of the population was Irish. In 1932, after the stock market crash and the ensuing chaos, Fiorello La Guardia was elected as mayor and order restored to a city now riddled with corruption and chaos.

View of Manhattan (3)
Chinatown (4)
Parade on Fifth Avenue (5)

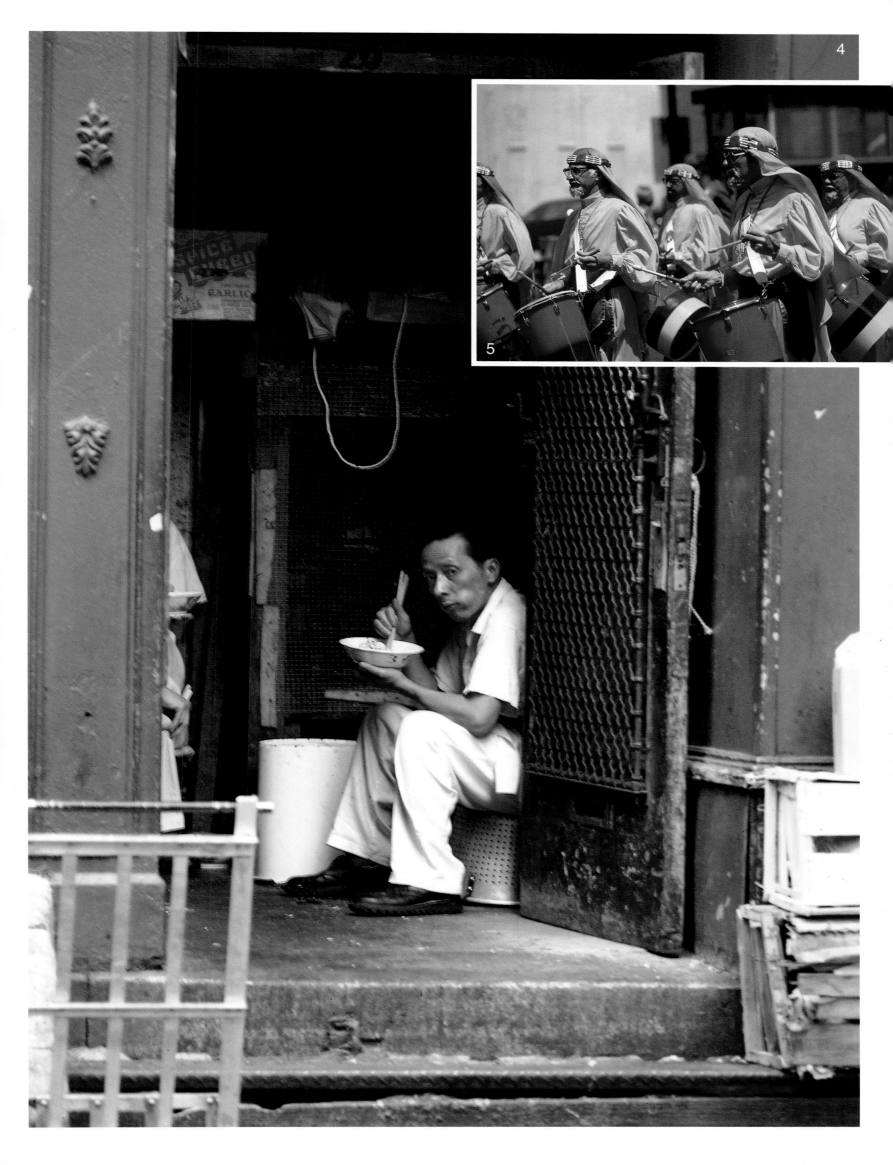

5

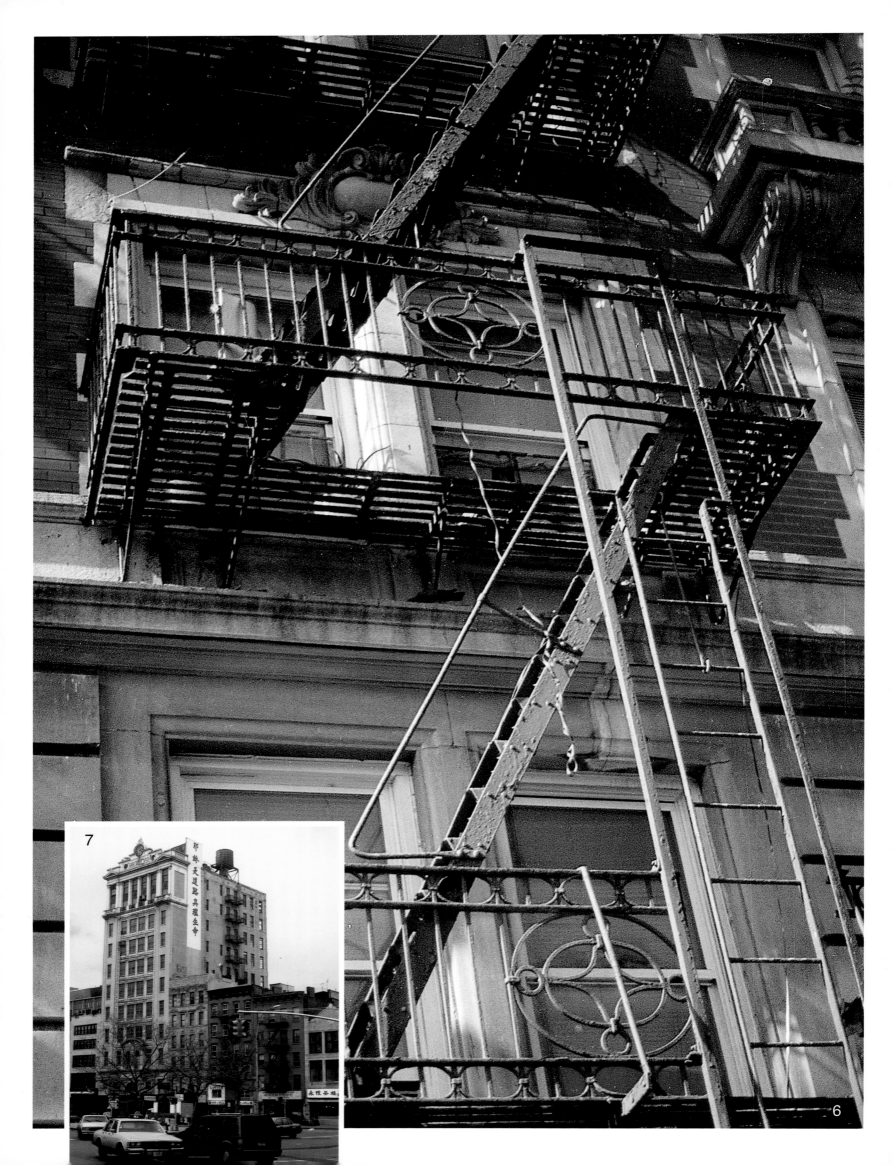

7

6

8

9

Daily life in Harlem (6–9)

He launched the most extensive public housing programme in the country and, in a spirit of optimism and prosperity, up went some of the city's most famous landmarks: the Chrysler Building, the Empire State Building and the Rockefeller Center. German artists fleeing Nazi persecution all flocked to this mythical haven of tolerance in a pattern that is still followed today as arrivals from Asia, Latin America and the former Soviet Union flood into a city that remains a collection of small, ethnic communities with a foreign-born population of more than two million – one million of them illegal. With its eight million inhabitants, 2,000 murders a year and 3.5 million commuters, it is a jumble of life, noise and sound – louder, brighter, more vibrant than almost any other city on earth.

Architecture: an introduction

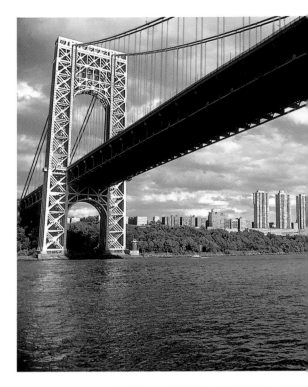

Le Corbusier referred to the city's 'beautiful catastrophe'. It transformed rapidly from the neat rows of traditional Dutch houses to the Georgian splendours of the British – whose only remaining relic in a constantly transforming landscape is St Paul's Chapel, built in 1766 by Thomas McBean. It was the British, however, who started a business venture in 1664 that would define the new city. They parcelled off plots of land, exposed only at low tide, and sold them to merchants hungry to snap up their own share in the new continent and fill in the swampy soil with any debris they could find. The concept of 'landfill' was born.

During the late eighteenth century the Federal style became *de rigueur* and it reached its heights with City Hall. Designed by Joseph Mangin and John McComb Jr, it boasts twin spiral stairs and one of the city's finest public interiors. The early nineteenth century is best represented by the aristocratic 'Greek Revival' town houses in Washington Square, but Brooklyn Heights remains the showcase for the nineteenth century townhouse, with its spectacular views of Manhattan and the all pervasive brownstone buildings which Edith Wharton referred to as a disgusting kind of cold chocolate sauce.

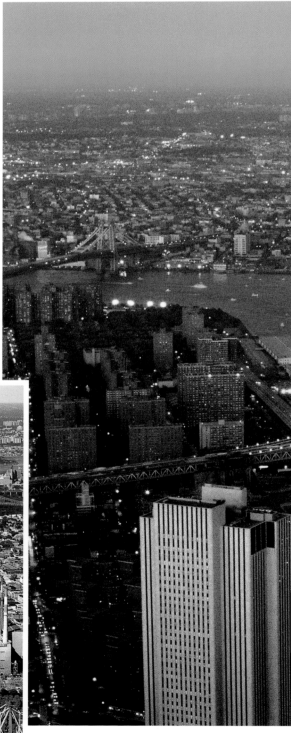

For today's tourist, however, one of the most important developments of the nineteenth century took place in 1811 when the city's commissioners started work on a new grid system which would transform New York. An engineer called John Randel Jr was contracted to survey Manhattan and to slice up the land into a horizontal plane of 2028 rectangular blocks and thereby to create the numbering system which still applies today and means that visitors (and residents) can never get lost.

In 1858 Central Park was created synthetically and thousands of middle-class New Yorkers seized their chance to move north. The Lower East Side had become, according to Henry James, 'a ghastly little world of bars and perches and swings for human squirrels and monkeys' – many advertising 'Standing Room' in hallways for three cents a night.

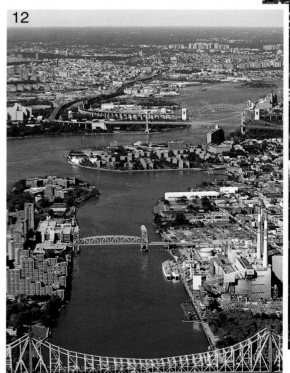

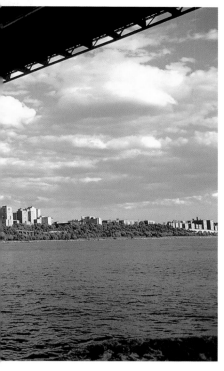

Williamsburg Bridge (10)
View of Manhattan Bridge (11)
View of Manhattan (12)

Next page:
View of Brooklyn (13)
View of Manhattan (14)

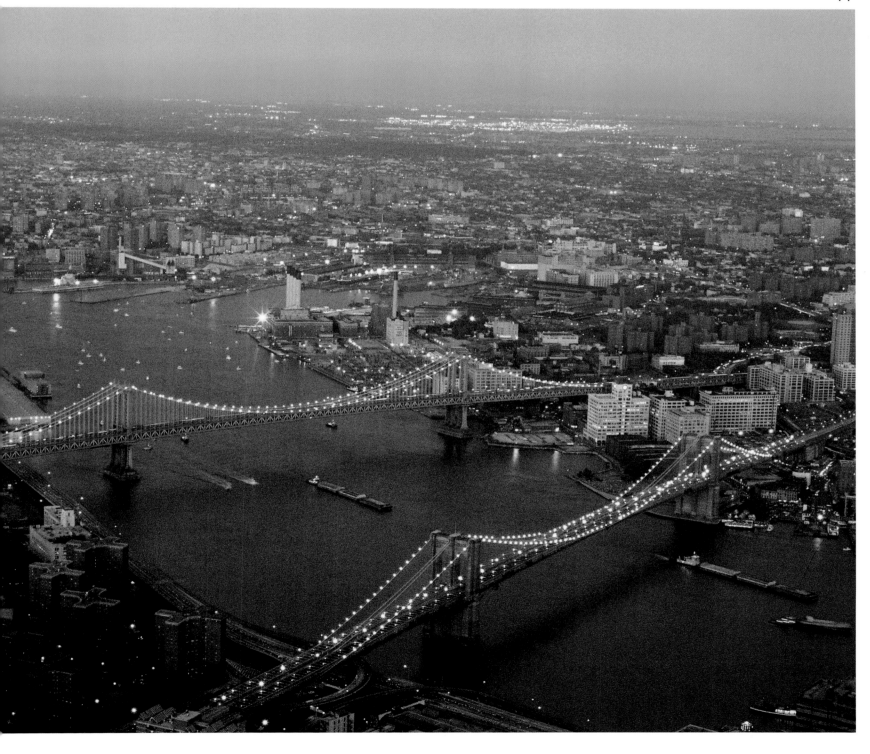

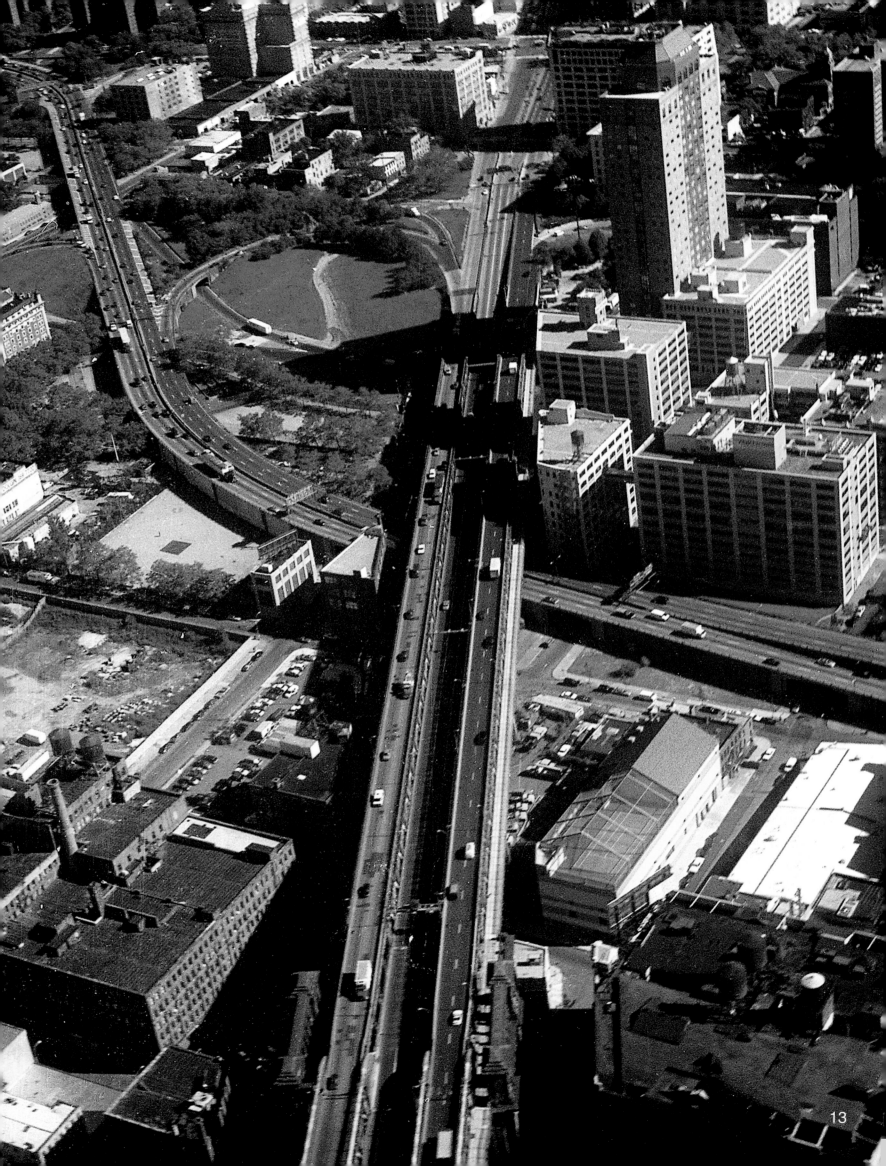

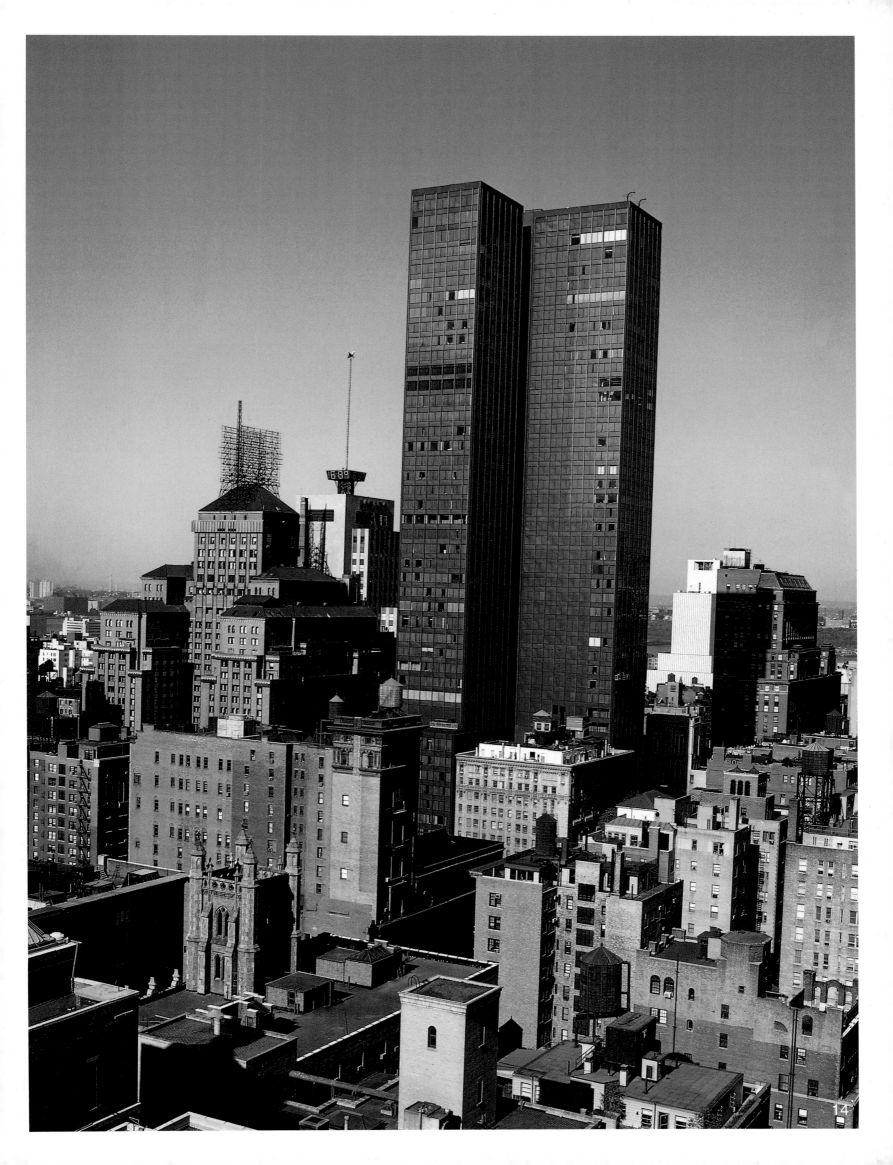

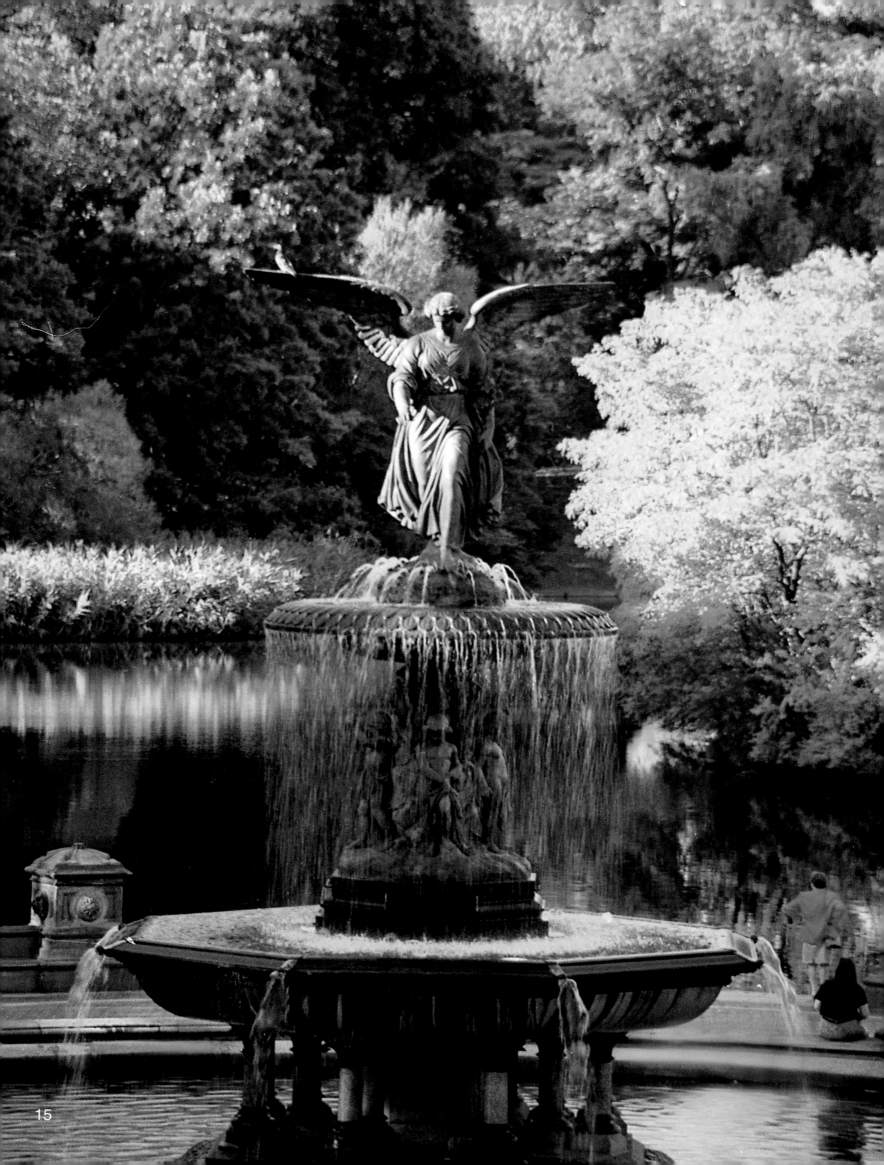

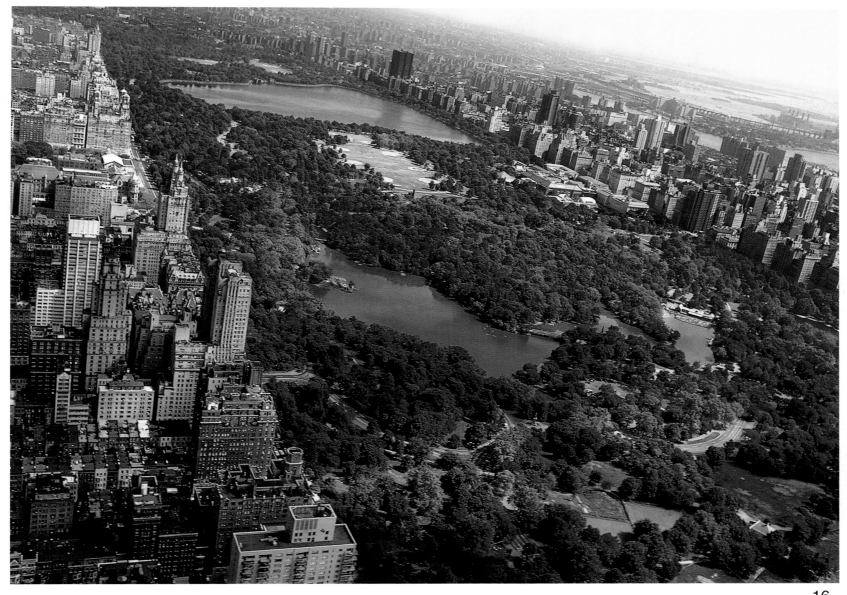

Environmental laws in 1929 phased out these tenement buildings but all the nice people had already moved to the first real apartment buildings on the newly gentrified (because of Central Park) Upper West Side. Here the Ansonia, the Dakota and the Dorilton imitated French chateaux and their interiors were equipped with all the latest mod cons including central heating and air-conditioning.

The invention of the elevator in 1857, meanwhile, made all things possible. The first working example was installed in the new Haughwout Building that year and architects quickly began to explore its potential. In 1913 Cass Gilbert constructed the Woolworth Tower, the tallest building in the world, while in 1916 the Zoning Law introduced a new, vertical grid plan which stated that, at a certain height, buildings had to step back from the edge of the site on which they stood. A tower could rise as high as its builder could manage so long as it filled no more than twenty-five per cent of its plot of land and, once again, the skyline of Manhattan was transformed.

Central Park (15, 16)

17

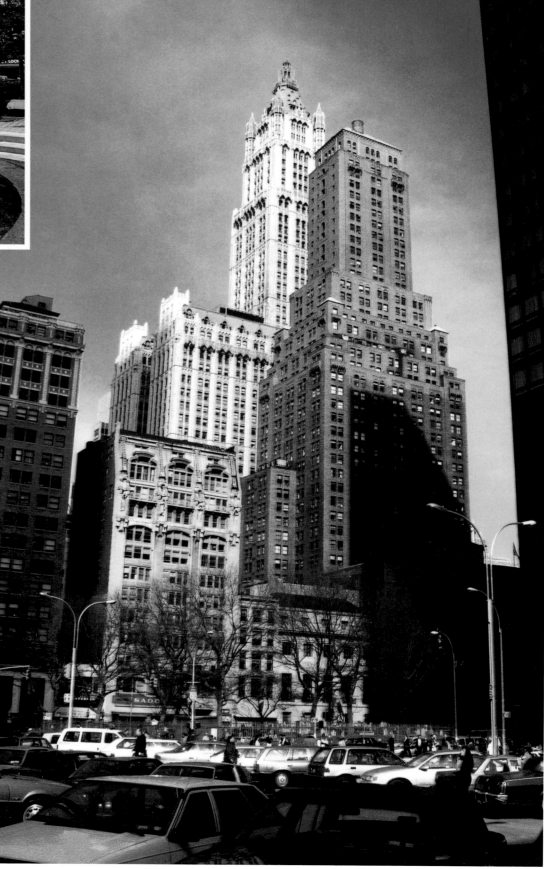

18

Woolworth Building (17)
Empire State Building (18)
Fifth Avenue (19)

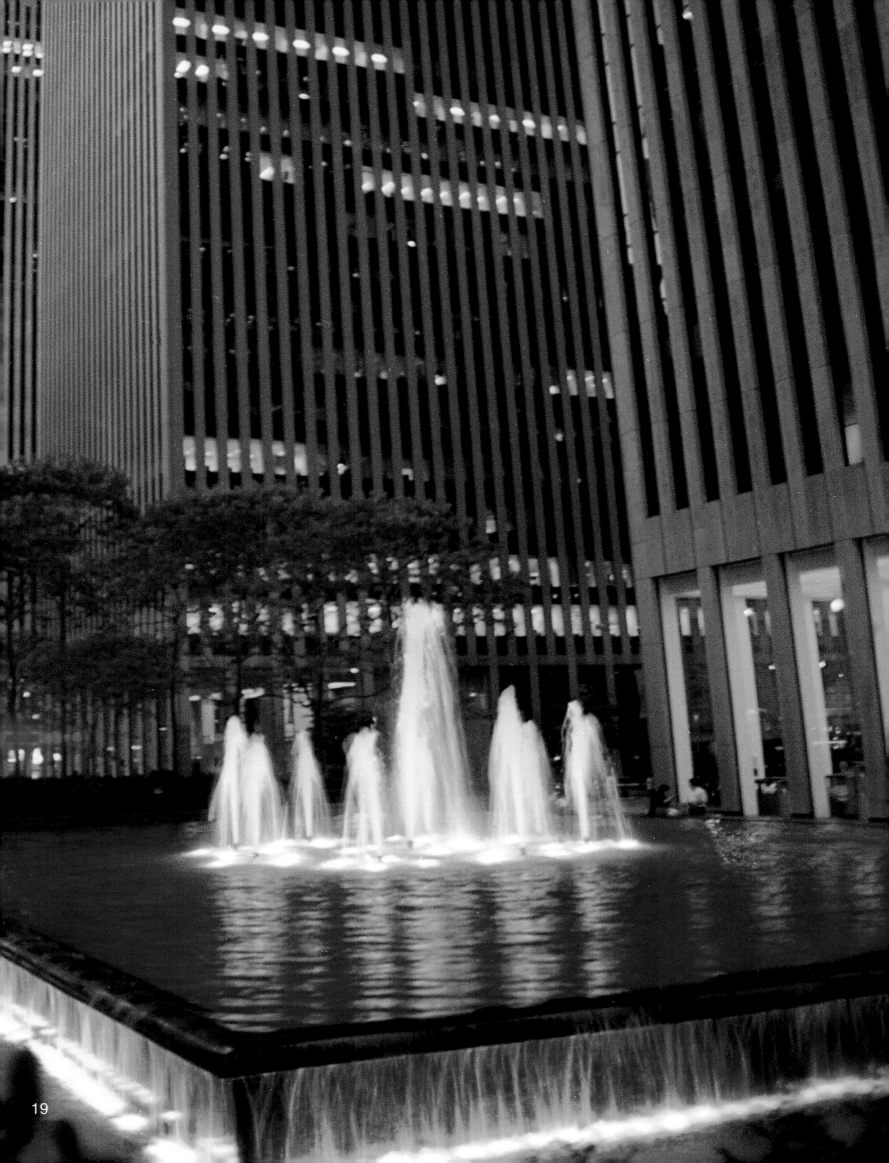

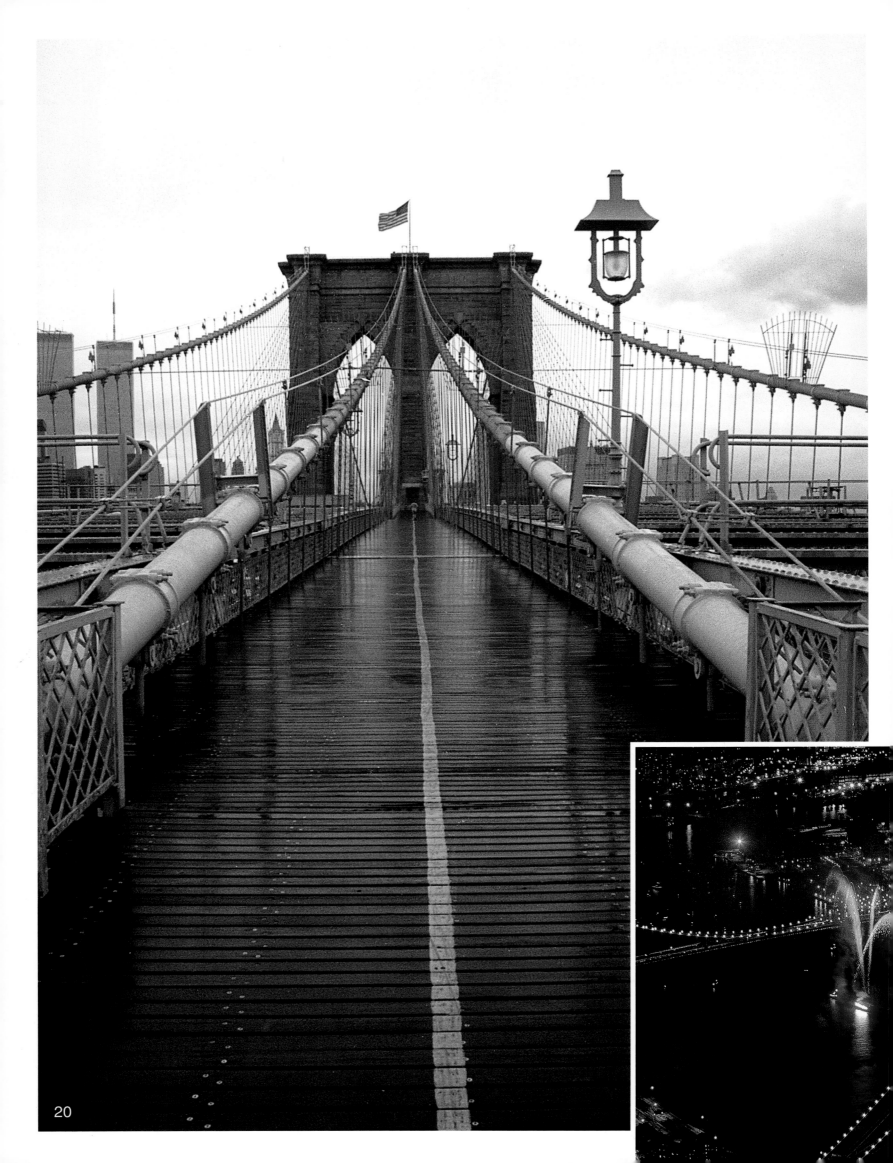

Wall Street and the Financial District

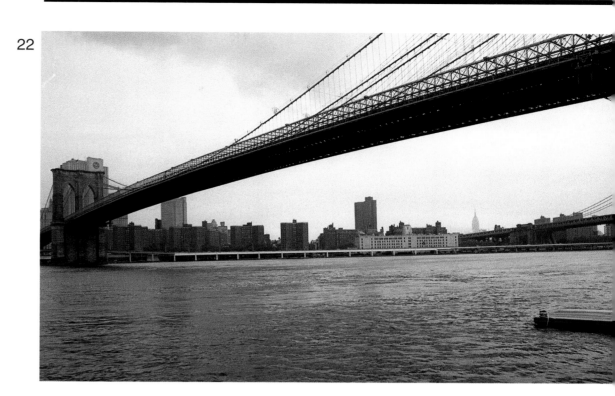

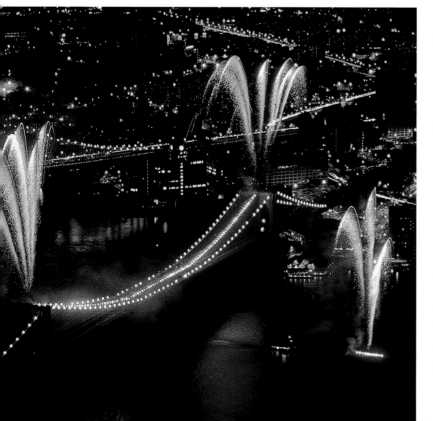

This is where the city began. As recently as 1960 the waterfront was still lined with elegant three-storey buildings, but this all changed when the financial markets boomed. Massive, boxy structures now face the East River and the fishy stench of Fulton Street Market has been replaced by the anti-perspirant of bond dealers. The only really historic building left is Cass Gilbert's US Custom House of 1907. This tribute to the city's role as a great seaport is a granite palace with a monumental flight of steps and four heroic sculptures each representing a different continent, but the building, constructed on the back of import duties, does not pay such homage to its own past and, literally, turns its back on both the harbour from which it drew its wealth and the bridge which, in most people's minds, represents the junction between the modern and the old.

Brooklyn Bridge was the dynamic handiwork of an engineer called John Augustus Roebling, a keen student of Hegel who came to America in 1831 to live on a utopian farming community near Pittsburgh. It stands for a city that prizes movement and energy above all things and it took six hundred men over sixteen years to build. When finally completed in 1883 it was the world's largest suspension bridge and the first to be constructed of steel.

Whilst surveying the site, Roebling's foot was crushed against the pier and his foot was infected by gangrene. A week before planning permission was granted, he died of tetanus. His son, Colonel Washington Roebling, took over the task but was crippled three years later by an attack of

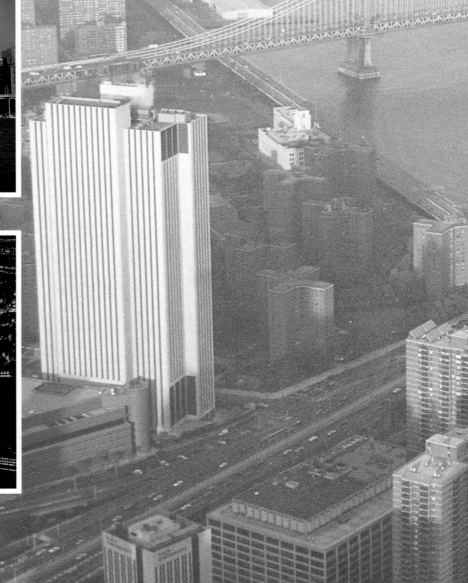

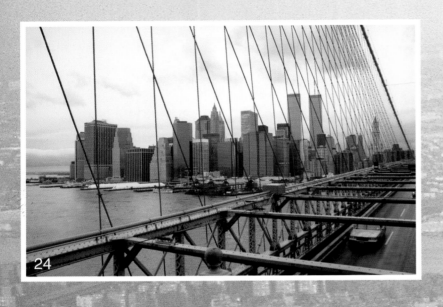
24

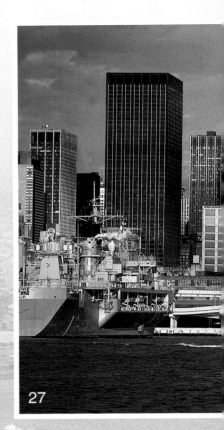
27

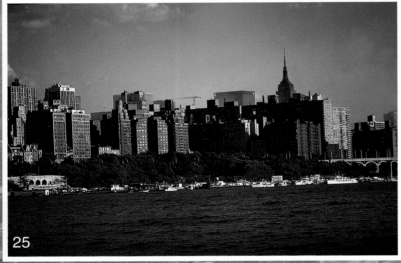
25

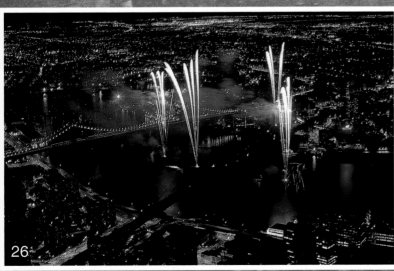
26

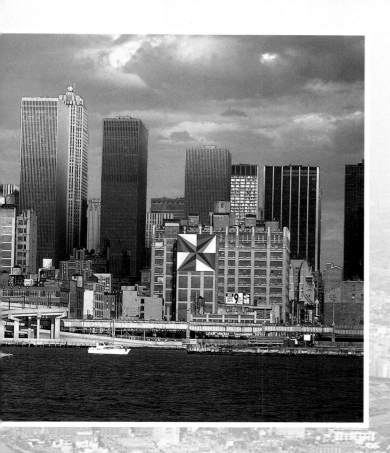

the bends – an illness which afflicted over a hundred men during the construction of the foundations. Washington then supervised work from a telescope in his living room in Brooklyn Heights. 'All that work just to get to Brooklyn,' joked the comedians but the bridge, with its perfect fusion of technology and art, now symbolises New York.

Standing on its iron walkway you see that other icon of the city that never sleeps – the Statue of Liberty. A gift from the French to the American people, this symbol of freedom was the brainchild of sculptor Frédéric-Auguste Bartholdi.

'Give me your tired, your poor, your huddled masses yearning to breathe free', states Emma Lazarus's poem, immortalised on Lady Liberty's massive pedestal – the largest concrete mass ever to be poured on the continent.

28

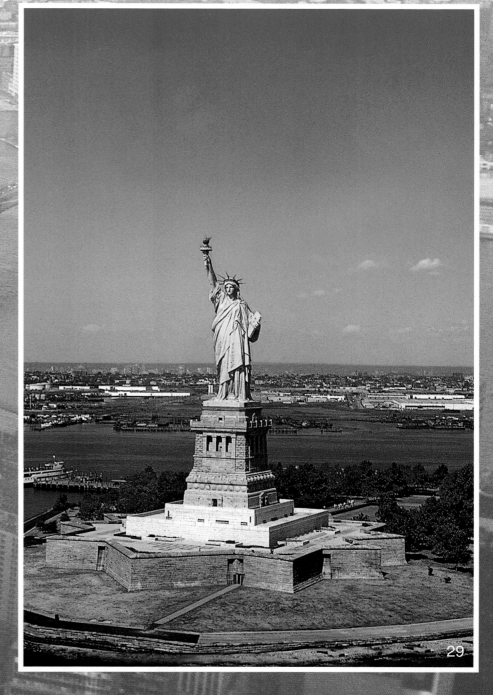

29

Bartholdi had an idea for a lighthouse in the form of a torch-bearing woman symbolising Progress and he commissioned Gustave Eiffel to construct an internal steel pylon to facilitate his dream. All 225 tons were presented to the US Ambassador in Paris but, during the re-assembly process, Congress ran out of funds. Other American cities eagerly put in bids for the exotic treasure but, after a bracing fund-raising campaign by Joseph Pulitzer, the Statue of Liberty was finally unveiled by President Grover Cleveland on 28 October 1886.

The view back onto the head of Wall Street takes in the New York Stock Exchange, which once housed the hub of the world's financial markets in a mere seventeen storeys, but these days it is the World Trade Center whose 110 storeys loom largest. Completed in 1982, more than a million cubic yards of earth had to be removed from the site and were transported to the nearby wharves as landfill, where they became Battery Park City. These two big, tall boxes, designed by Minoru Yamasaki bear no relationship to anything around them and Yamasaki's feat of modern engineering comes at the expense of humanity – the entire building is supported by load bearing walls and this structure, though radical, meant that the windows are only a foot wide and can never be opened.

30

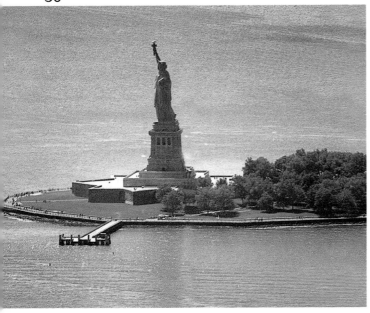

31

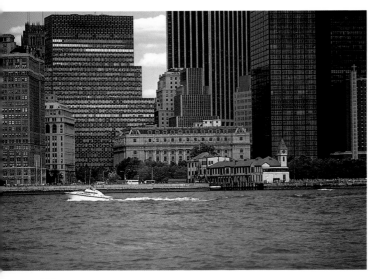

32

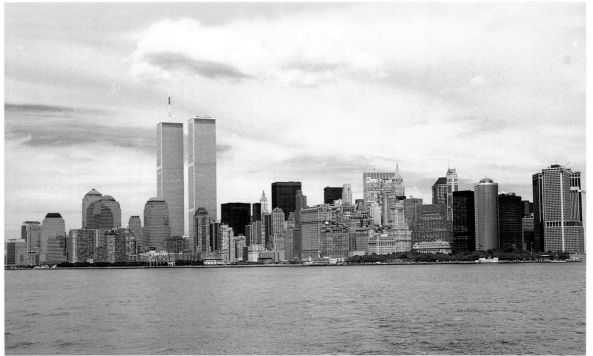

The Statue of Liberty (30)
Views of Manhattan (31–32)
The Port of Manhattan (33–34)

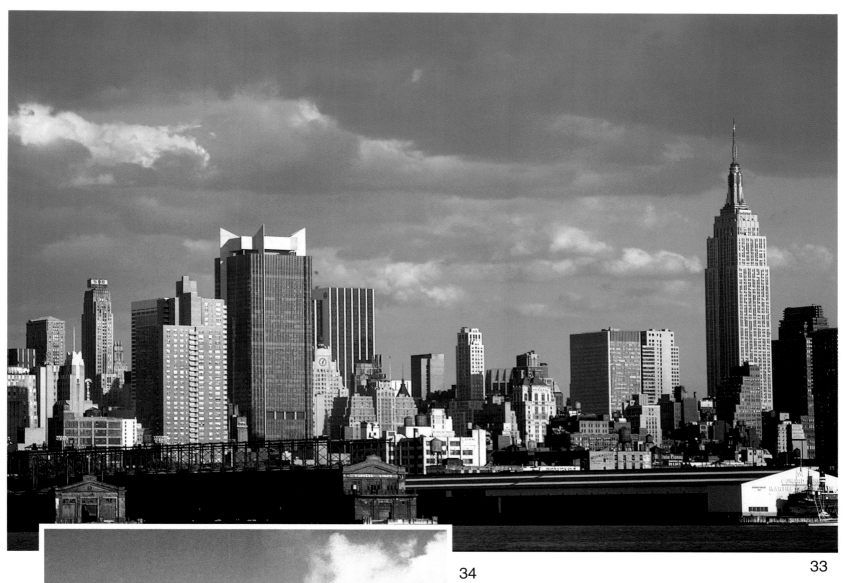

34

33

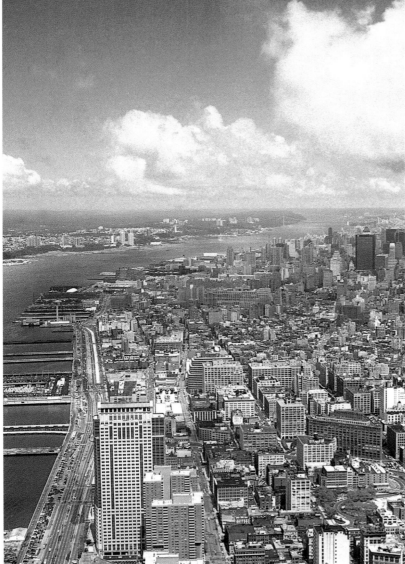

Next page:
View of Lower Port (Manhattan) (35, 36)

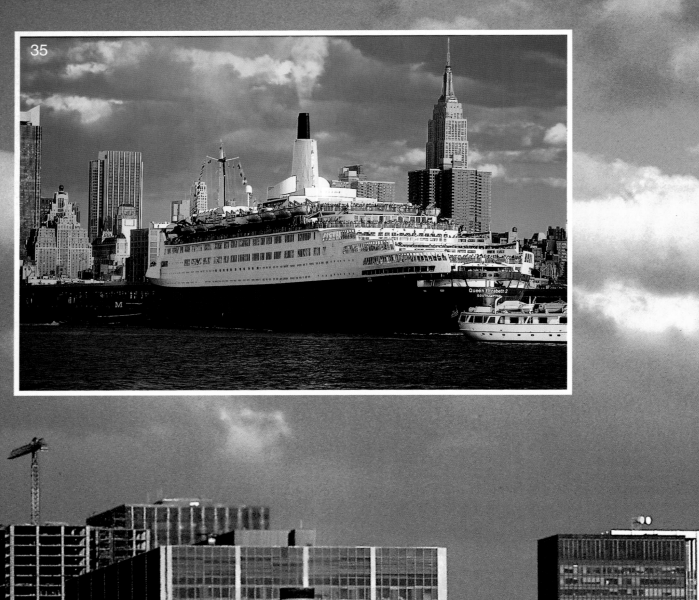

Lower East Side

Due north of the giddy heights of finance lie the diminutive dwellings of the Lower East Side. An endless cycle of immigrants have arrived and settled here only to make good and move out, leaving just enough room to squeeze in the next wave of optimistic arrivals. First came the Jews and then the Chinese and later the Italians. Now the area houses not just New York's oldest synagogue and its best known kosher deli, Katz's, but also the city's single largest ethnic neighbourhood. More than 150,000 people live in Chinatown or Gam San, the Mountain of Gold, but, these days, Mott Street is more likely to draw the foreigners with the scent of Dim Sum than with the prospect of hitting the financial jackpot.

Just north lies Little Italy, which had a population of 150,000 at the turn of the century but is now merely a fantasy pastaland. For nearly 75 years 'New York's Finest' came to work here at the awkwardly wedge-shaped Police Head-quarters Building but, in 1973, the law enforcers moved to new headquarters and now the building is just another conversion into luxury apartments.

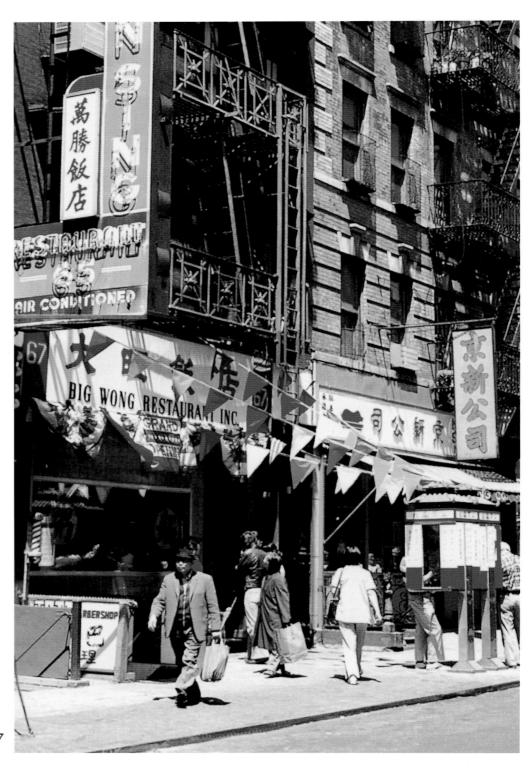

Chinatown (37, 38)

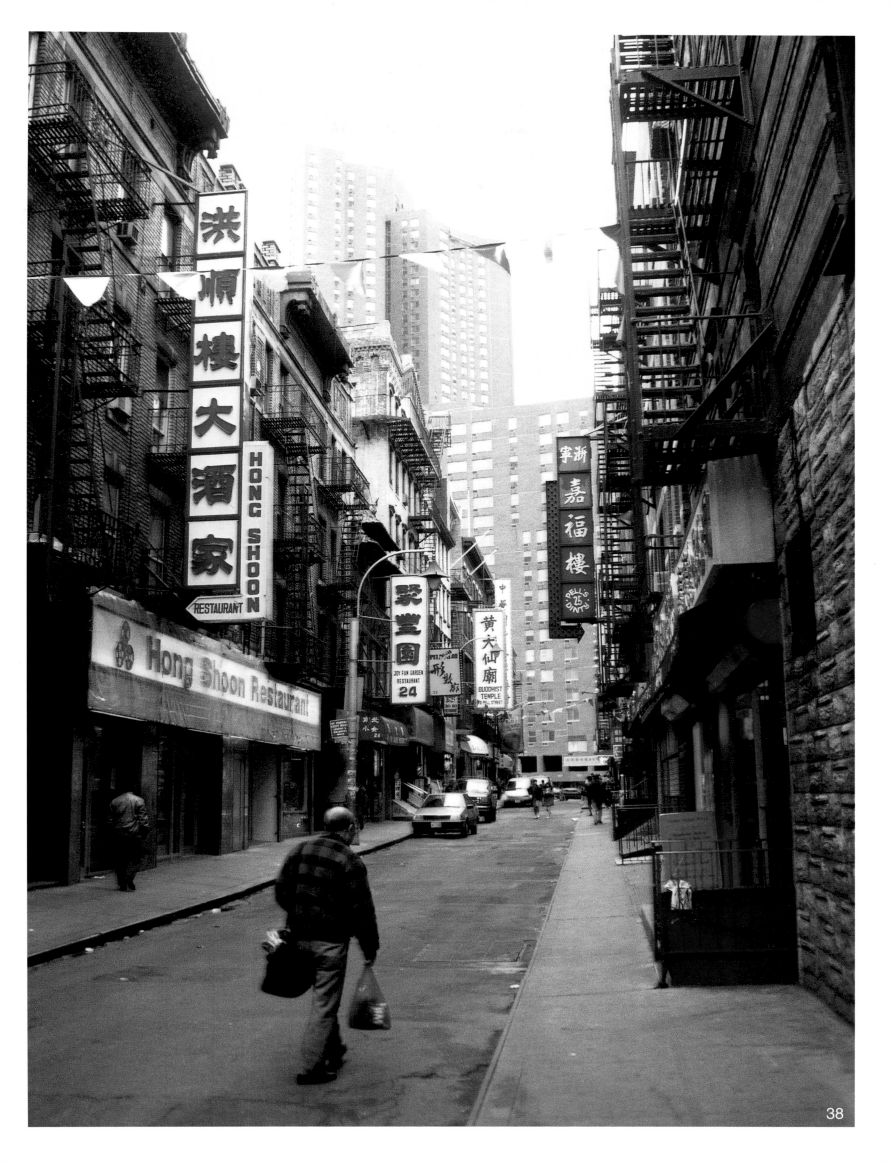

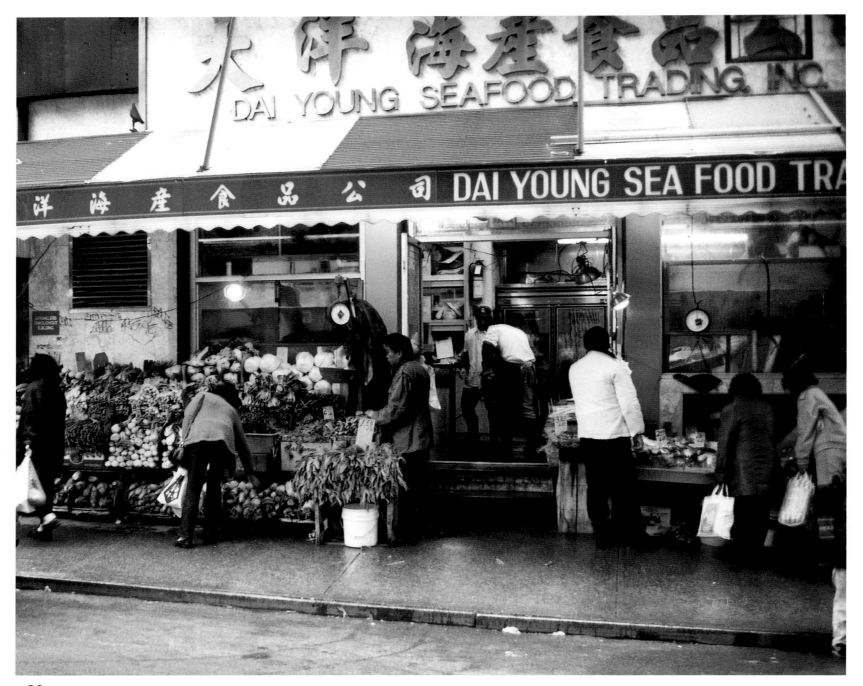

39

Chinatown (39, 40)

Next page:
Chinatown (41)

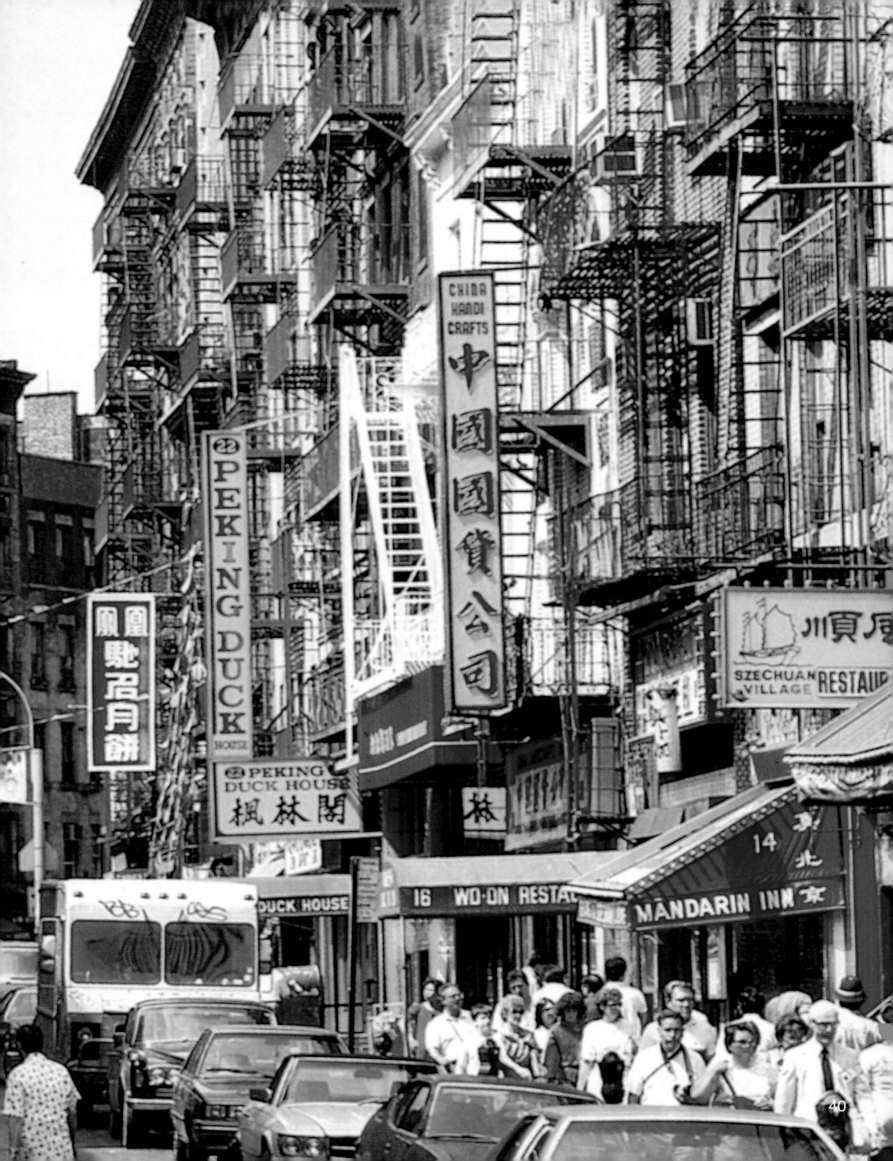

RESTA

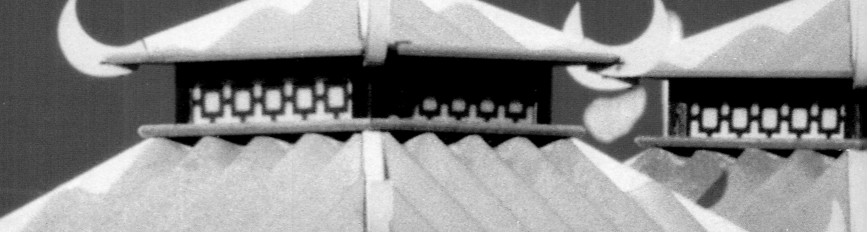

 New York Telephone

New York Telephone

Lower Manhattan: SoHo, TriBeCa, Greenwich Village

For many years the area below Houston Street was considered a wasteland and there was a comprehensive plan to level the buildings and replace them with a high-speed expressway. Local people, who had begun to refer to the area as SoHo (or South of Houston Street), objected and when the road scheme was finally abandoned in 1965, its old loft buildings were taken over by artists in need of large, cheap space. Now SoHo is an ocean of galleries and boutiques and no struggling artist could afford to live in this tidal wave of cast iron – the material that ushered in pre-fabrication but allowed for the kind of intricate detail that meant that no two buildings are ever exactly the same. In Broome Street and Greene Street the tension between the strength and the delicacy of cast iron is brilliantly resolved, while 101 Spring Street shows how it can allow great sheets of glass to

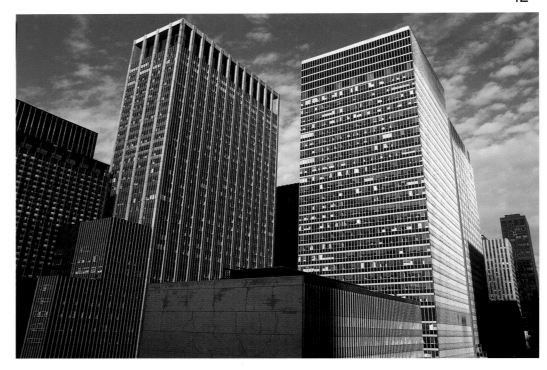

exist within a skeletal frame. The zenith of cast-iron work, however, is the Haughwout Building on Broadway, where everything fits together in a perfect blend of the ornate and the simple. Five storeys of windows, each with its own Corinthian columns, mean that the building can be looked at both horizontally and vertically – all vistas leading to a perfect, parallel whole.

Nearby TriBeCa (or 'Triangle Below Canal Street') is even ritzier – an entire neighbourhood of glorious industrial architecture where lofts and pot-plants have taken over from sewing machines and the area's most famous local, Robert De Niro, has opened the TriBeCa Grill. But from Duane Park, the local piece of greenery, it is still impossible to see the World Trade Center and only the Romanesque houses are visible in an oasis of residential calm.

From here West Broadway leads straight to Greenwich Village, which stretches from 14th Street down to Houston and whose myriad crooked streets defy the grid system with which everyone else in the city complies. The area began life as a true village and expanded dramatically during the yellow fever epidemic of 1822 when the well-to-do fled their houses and moved north. Many of today's highly-prized dwellings were put up rapidly by speculators, leading to the lack of uniformity that is now crucial to the Village's counter-culture identity.

Lower Manhattan (42)
Street in SoHo (43)

Flatiron Building (44, 46)
Fifth Avenue (45)

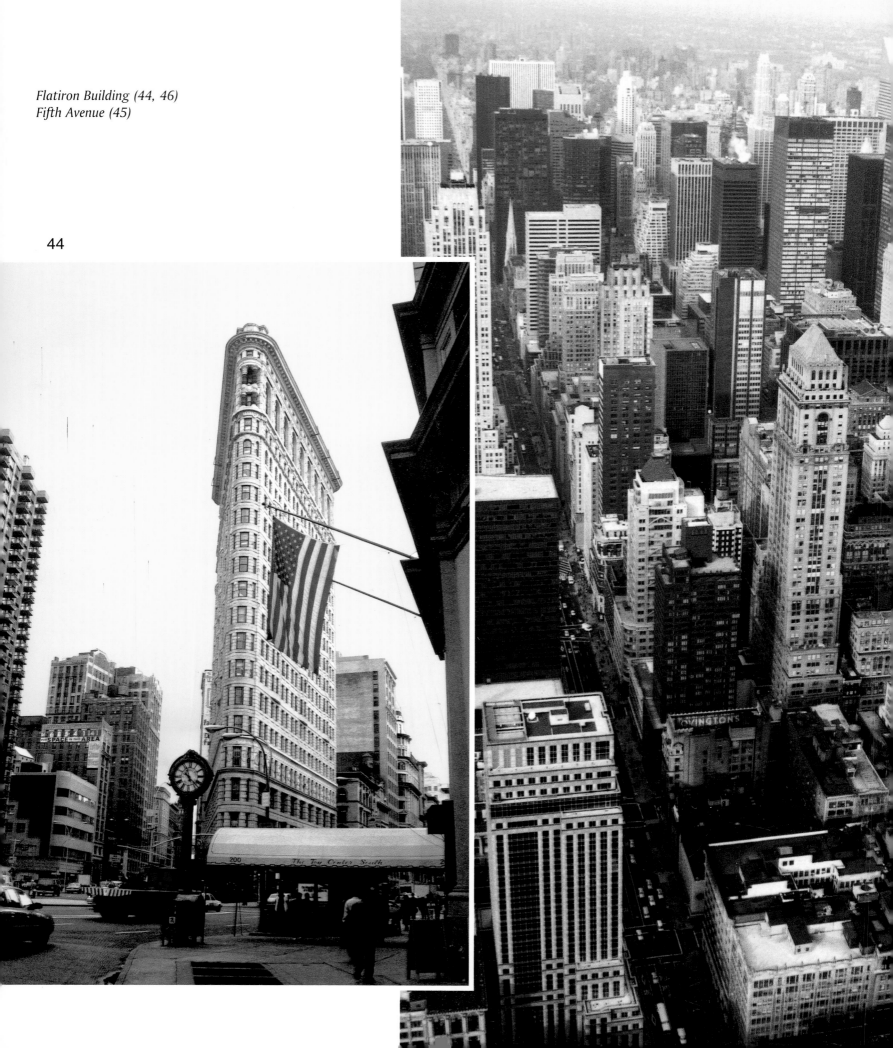

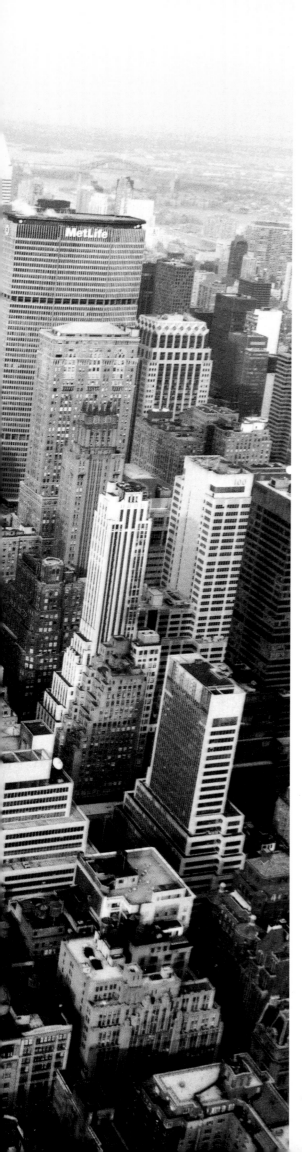

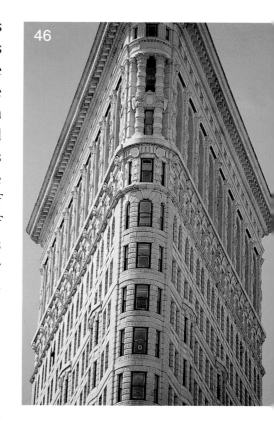

Washington Square Park, one of its best known landmarks, started life as a paupers' cemetery but by 1828 the city's most fashionable houses were built around its perimeter. In 1916, a group of artists led by Marcel Duchamp climbed to the top of its famous marble arch and declared the 'free and independent republic of Washington Square' – a feat of surrealist revolution which was replicated in 1964 when community activists managed to persuade the Transit Authority to make its buses turn around elsewhere and, thereby, restore the park to pedestrians. The marble facades of the Greek Revival houses that still stand on the north side of the square testify to their aristocratic past, while the proximity of New York University, architecturally unified (though not attractively) in the 1960s by Philip Johnson and Richard Foster, means that the whole southern area of the square is now rather better known for all those aspects of life that go along with studentdom: rollerbladers, druggies and jugglers.

At first the Village and the Flatiron District, its northern, businesslike neighbour, could not seem more different. Both, however, started out as health sanctuaries for the affluent and both had, by 1900, become hotbeds of radical art and politics. While the artists gravitated downwards towards the Village, the two great squares in the Flatiron district – Madison and Union – became flashpoints for mass meetings and political rallies.

Union Square is not named after any federal celebration but is merely a label for the junction between Bowery Road and Broadway – the city's main routes in the early nineteenth century. At number 33 Union Square West lies a wildly eclectic building sporting an absurd facade of Gothic and Moorish styles. Every kind of moulding plays a role here and the top bursts into a wild explosion of stylistic eclecticism. Though the occupants now sell tracksuits, this was, in a more exotic former incarnation, the site of Andy Warhol's film studio, The Factory, and the place where, in 1968, Valerie Solanis strolled in and shot him for turning down her script.

Straight up Broadway, past a myriad of fine nineteenth century buildings formerly known as Ladies Mile, is the Flatiron building itself. Its triangular shape, which was merely a necessary response to the awkward site between the intersection of Broadway and Fifth Avenue, quickly earned Daniel Burnham's 1902 Fuller Building a new name and the finished building was an instant hit with locals, while its French Renaissance, limestone facade earned it a place in the critics' hot lists. It was Burnham's finest creation and one which, deservedly, gave its name to the entire surrounding area.

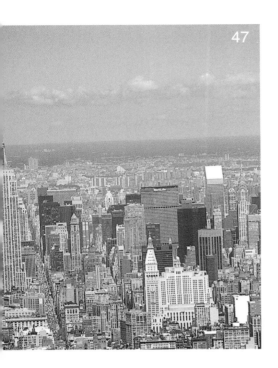

47

From here Fifth Avenue takes you straight to 1931's star novelty – the Empire State Building – most famous for being tall. Its sheer height and its graceful setbacks are broken up by delicate indentations and its granite, aluminium and nickel facade creates just the right nuance of Art Deco styling. Here William F Lamb created a structure of such solid dignity and texture that it remains a symbol of New York almost seventy years on – partly due to its legendary starring appearance in the finale of the 1933 classic film *King Kong*.

Fifth Avenue (47)
Washington Square (48)
Hall of the Empire State Building (49)
Bird's eye view of a
Manhattan avenue (50)

Next page:
Empire State Building (51)
Radio City Music Hall (52)

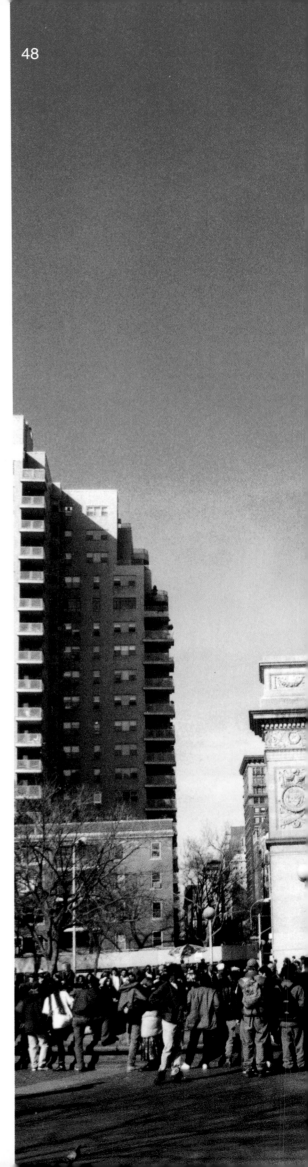

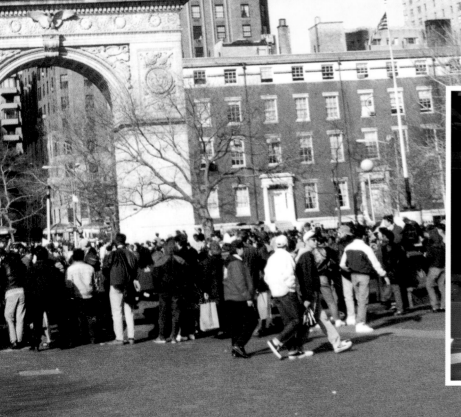

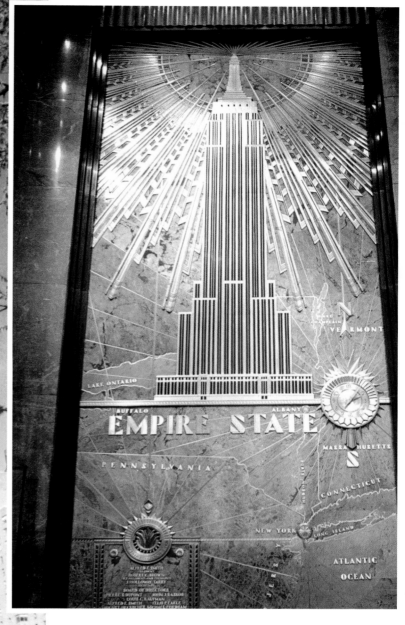

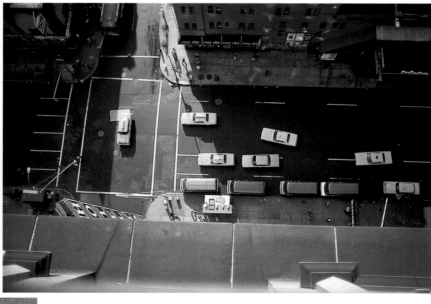

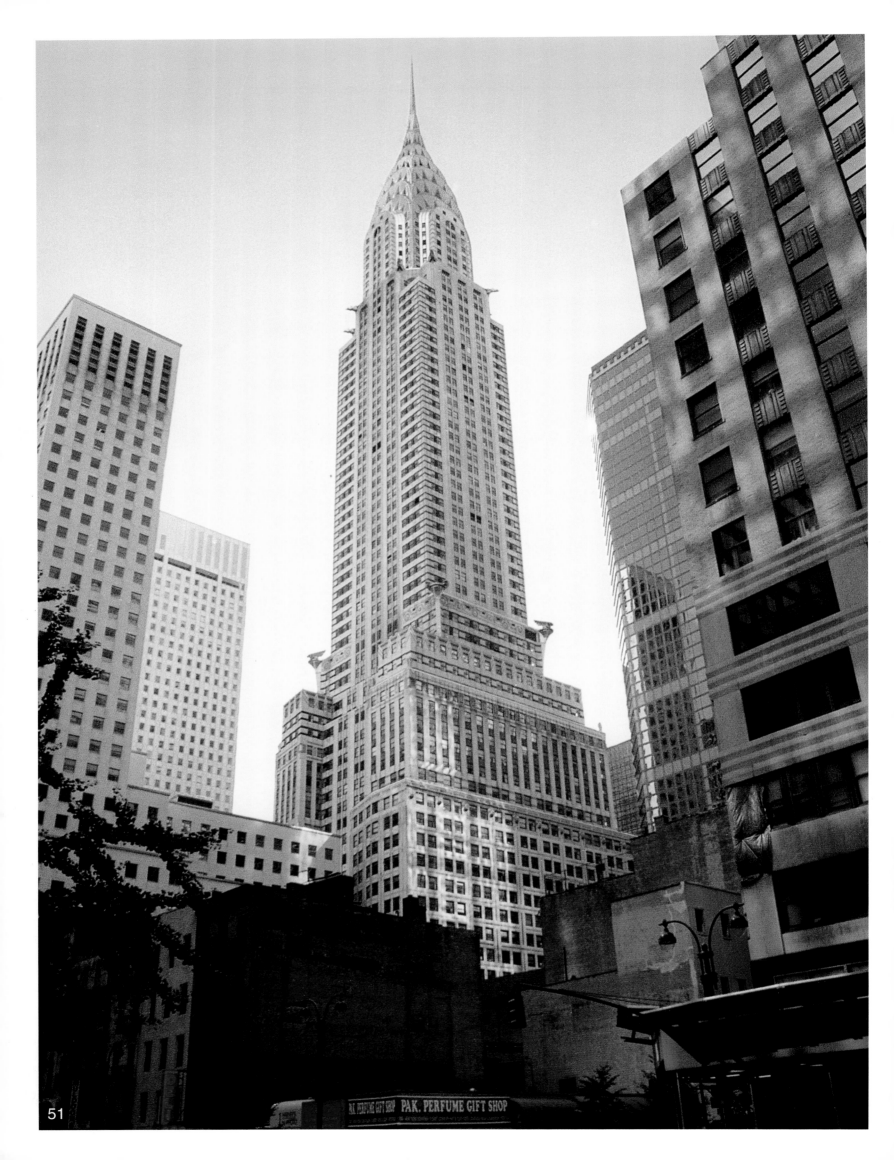

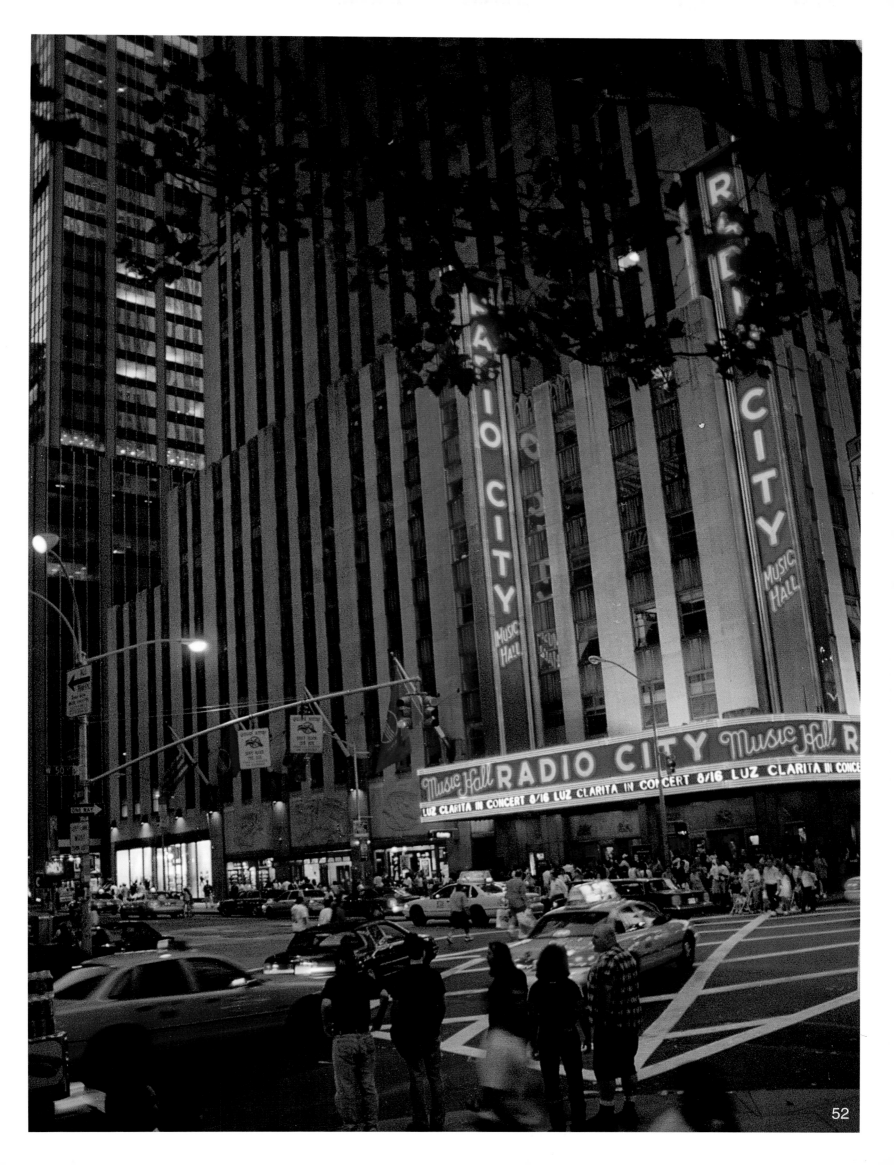

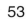
53

54

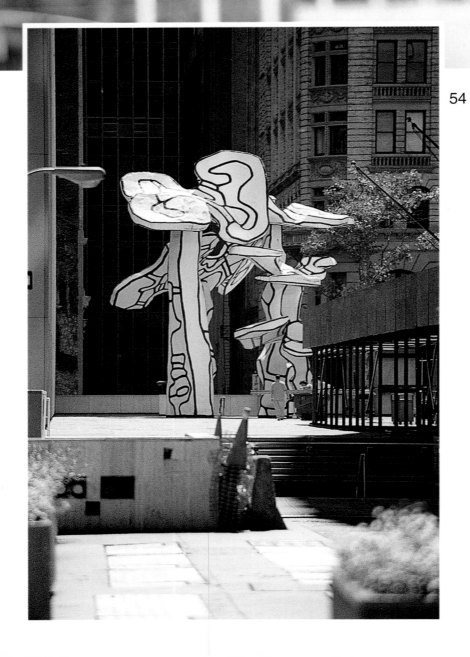

*Sculptures on Fifth Avenue in Midtown
(Manhattan) (53–55)*

Next page:
World Trade Center (56)
Reflection on building in Manhattan (57)

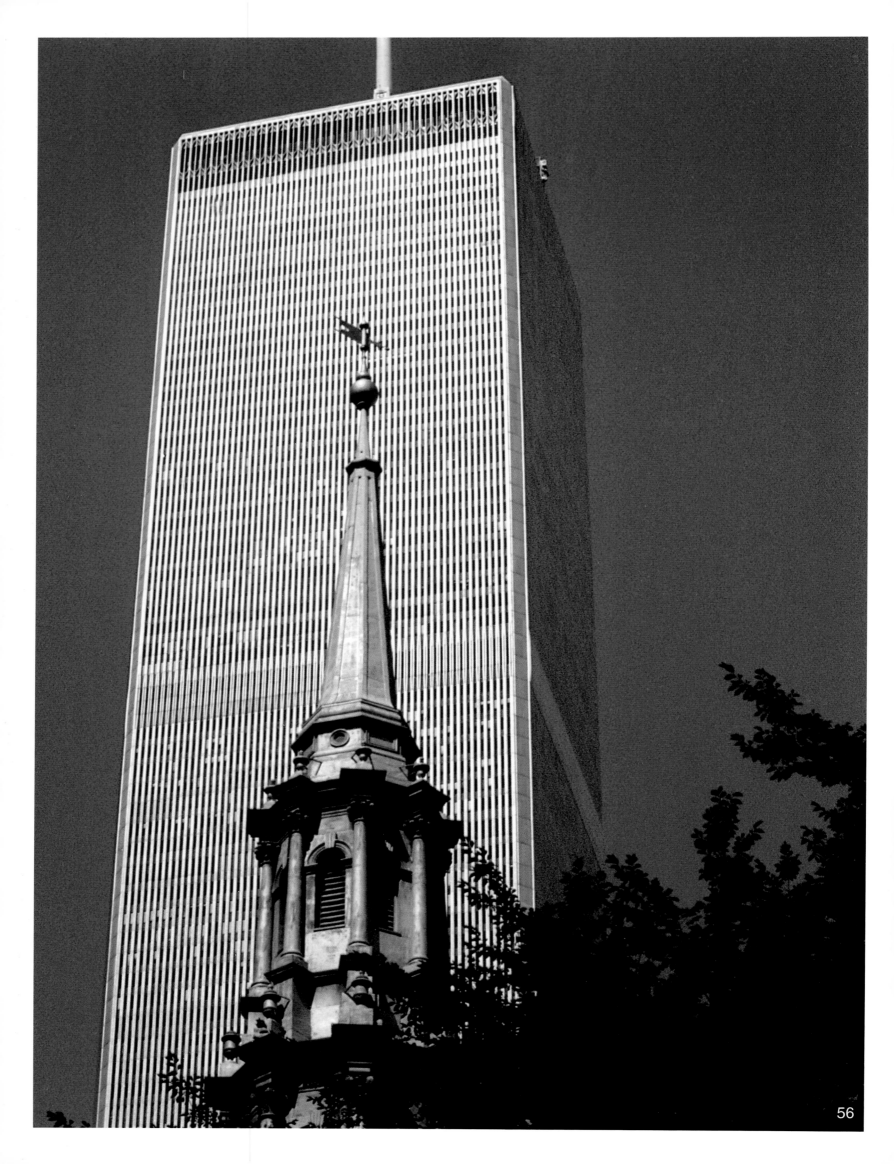

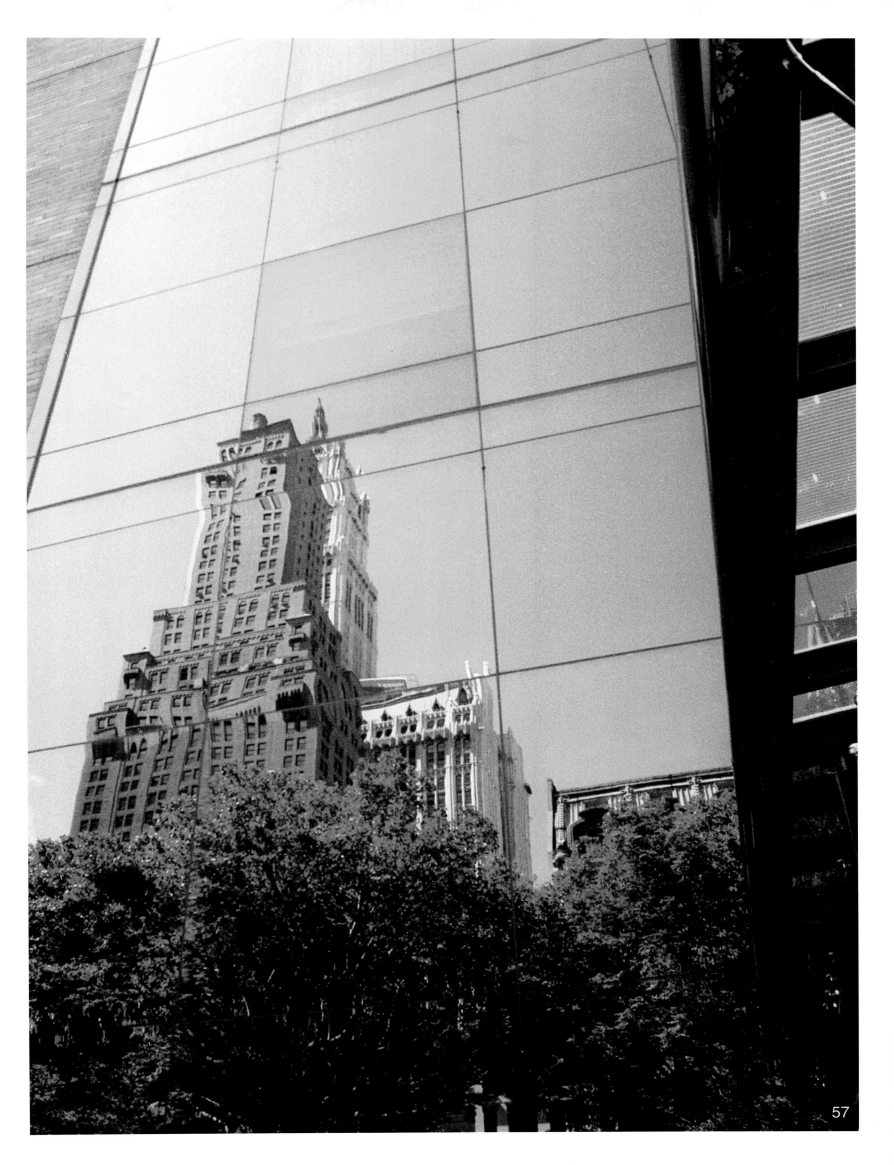

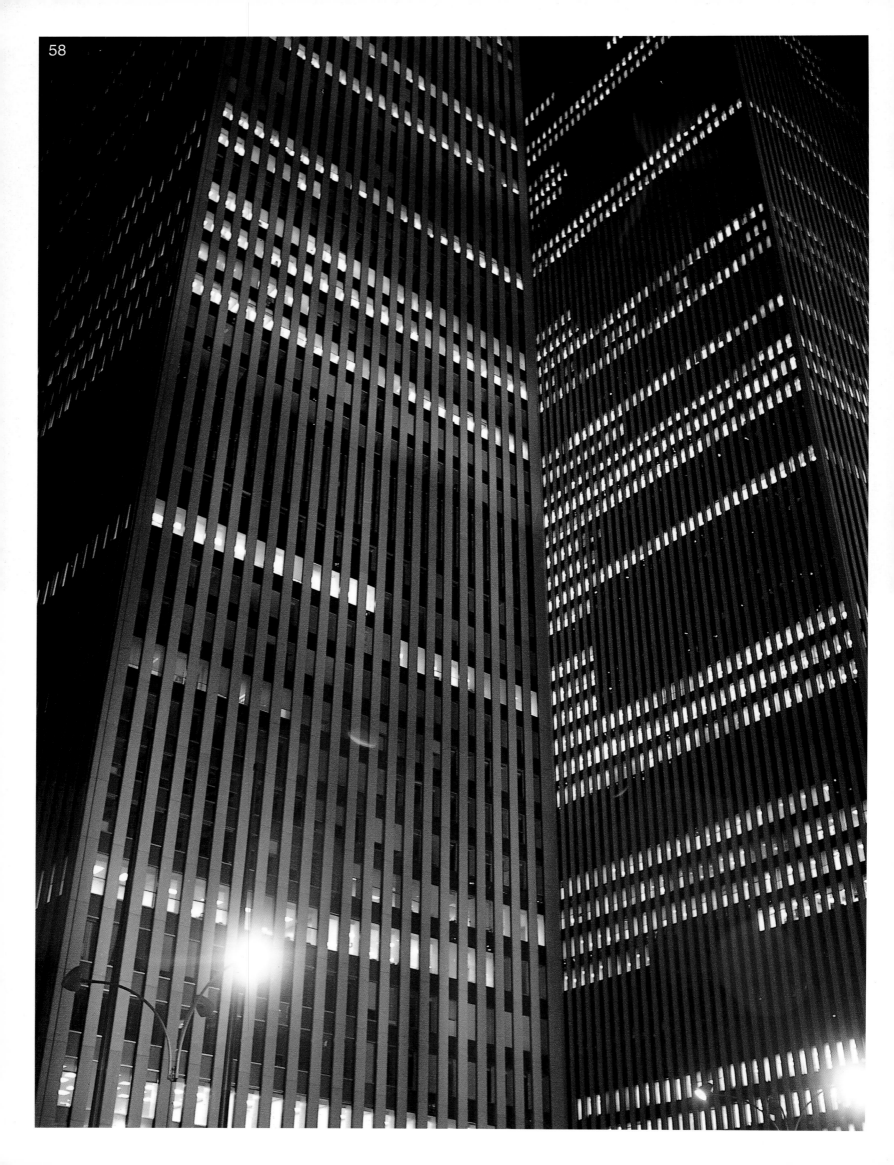

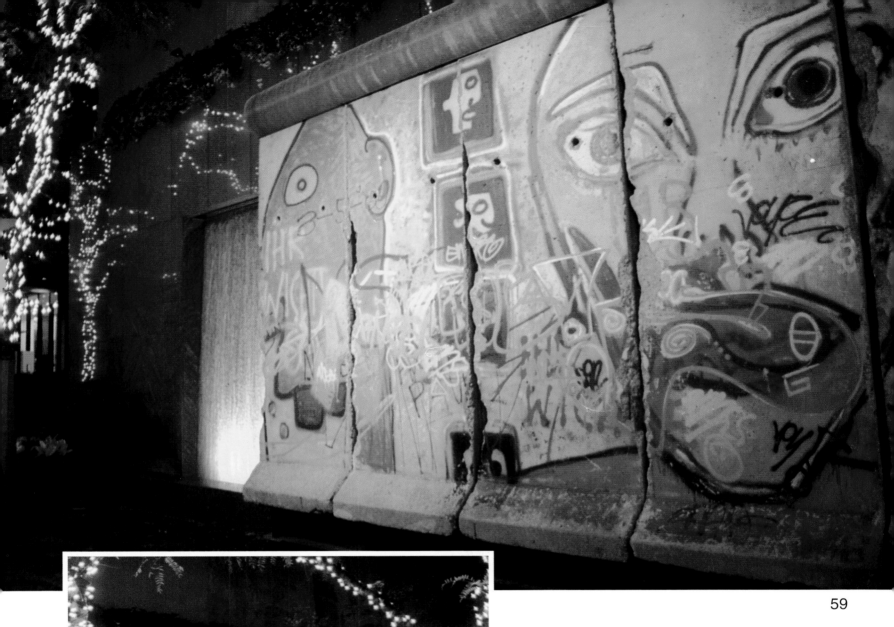

Park Avenue's Seagram Building (58)
A piece of the Berlin Wall
in Midtown (59, 60)

60

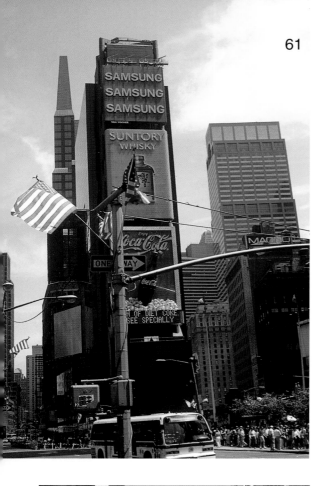

Midtown

Here, at the most famous of all Broadway's many intersections, lies Times Square – the centre of the city's theatre district since the late nineteenth century when the Metropolitan Opera opened at 40th Street. Longacre Square, as it was known, was renamed to honour *The New York Times* in 1904 when the newspaper moved from downtown to occupy the Times Tower. In 1928, the *Times* used the world's first moving sign to post the election results in the Square but, these days, the esteemed local paper is run from West 43rd Street and no-one regretted the move. The area has been revitalised by the Disney Corporation, but even the 1903 New Amsterdam Theater, its most opulent edifice and the home of the Ziegfeld Follies, is now dark.

The two high points of the city's Beaux-Arts heritage also lie nearby. New York Public Library (Carrere & Hastings, 1911), with its triple-arched entrance guarded by E C Potter's famous sculpted lions, now forms the focus of one of the city's finest outdoor plazas while Grand Central Terminal, massive and handsome, results from the fact that New York's railway tracks were, at one time, open to the sky and needed to be covered. William Wilgus, the chief engineer, proposed an entirely new terminal with an ingenious separation of car, pedestrian and subway traffic and Warren & Wetmore were brought in to design the sumptuous facade. The architectural triumph, however, is the main concourse. The Supreme Court upheld the city's right to declare the building a landmark in 1978 and it has now been lovingly restored to its former glory.

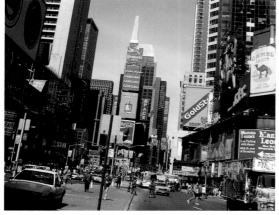

The Chrysler Building to the east was the dream of Walter P Chrysler, who began his career in a machine shop but ended it as the head of the car corporation bearing his name. His desire to build a fitting tribute to the industry that had made him a millionaire led to a 1931 skyscraper topped by six levels of stainless-steel arches and a spire, all representing parts of a stylised car. Though it lost its title as the world's tallest building only a few months after it was completed, its lobby remains one of New York's finest Art Deco interiors.

Midtown (61–64)

Next page:
Radio City Music Hall (65)
Views of Manhattan (66, 67)
Reflection on a building (68)

Fifteen years later John D Rockefeller Jr donated $8.5 million to purchase a site on the East River 63

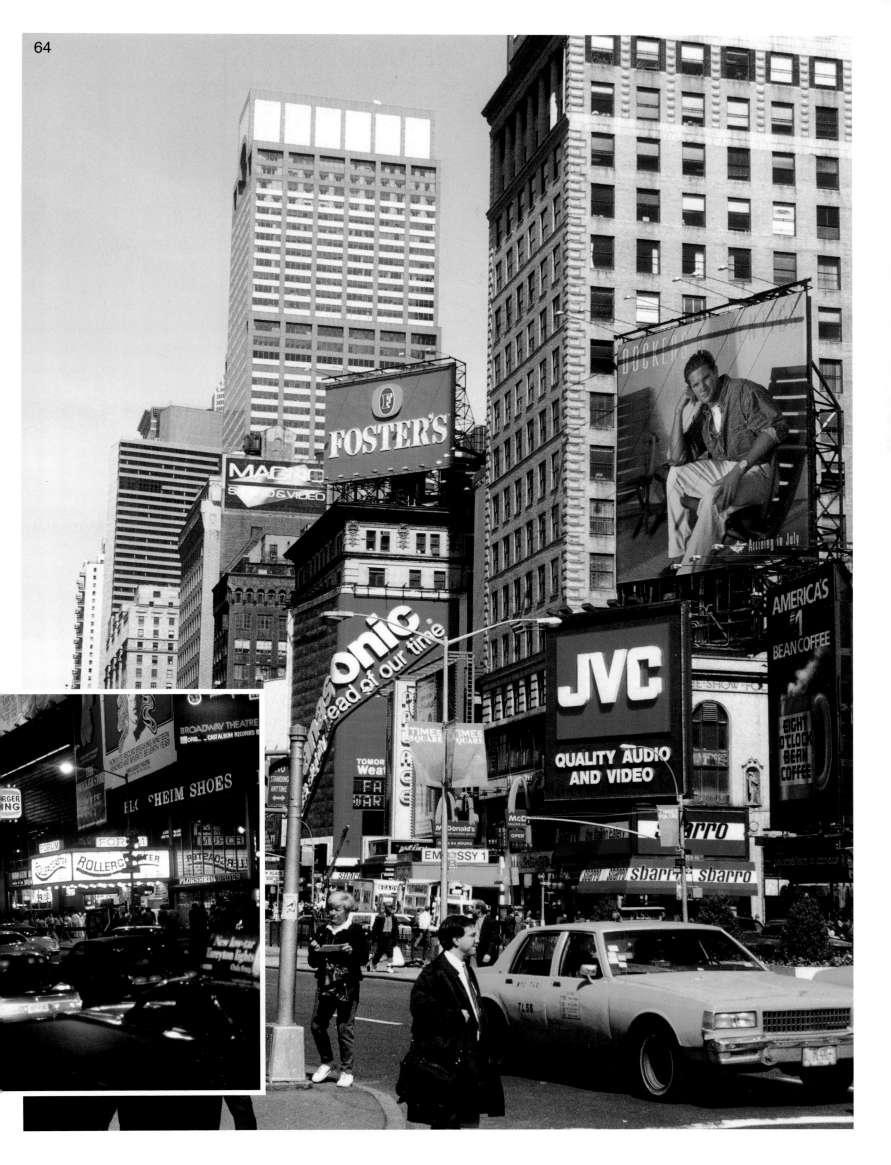

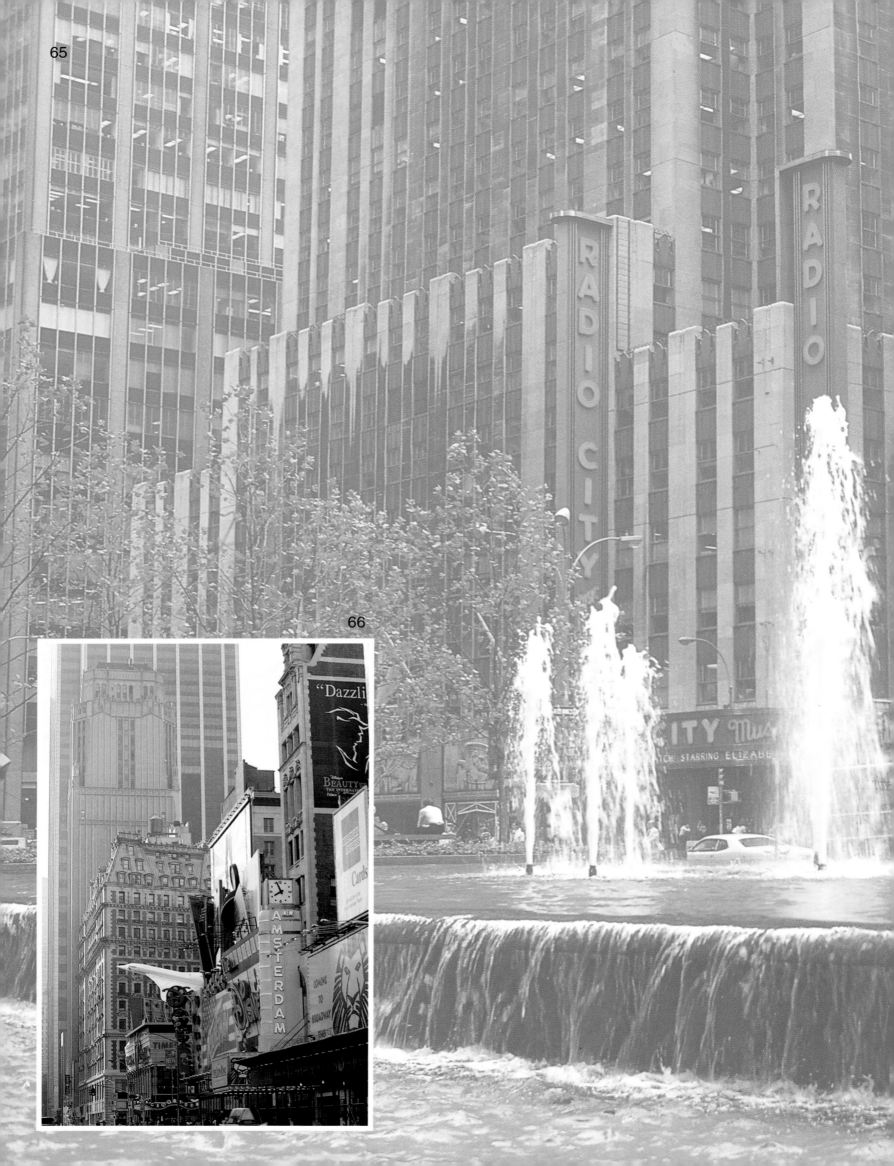

65

66

for the new UN headquarters and the 18 acre United Nations Headquarters is not on US territory but is an international zone. Le Corbusier was brought in to create three innovative buildings but he quickly renounced any association with the problem-ridden project. The 39 storey glass-walled Secretariat suffers from terrible air-conditioning but is still the only skyscraper in Manhattan with acres of space to call its own.

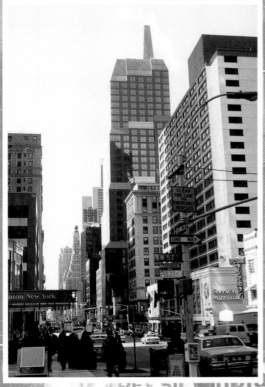

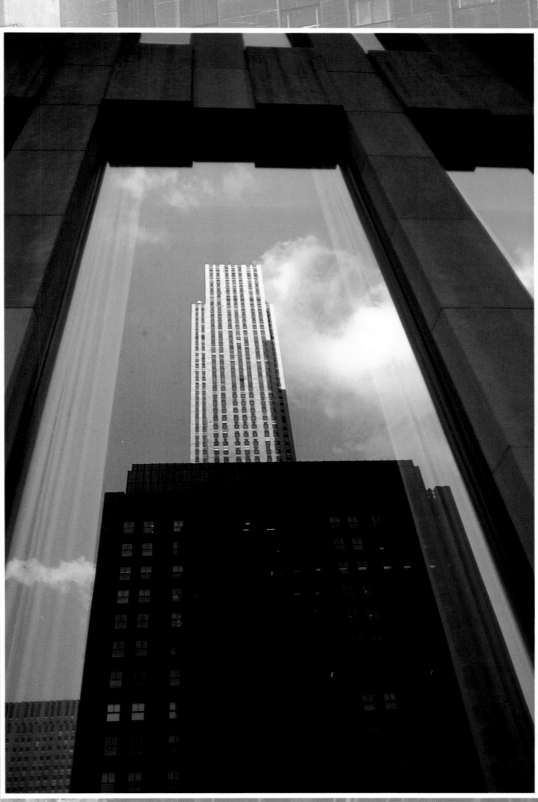

67

68

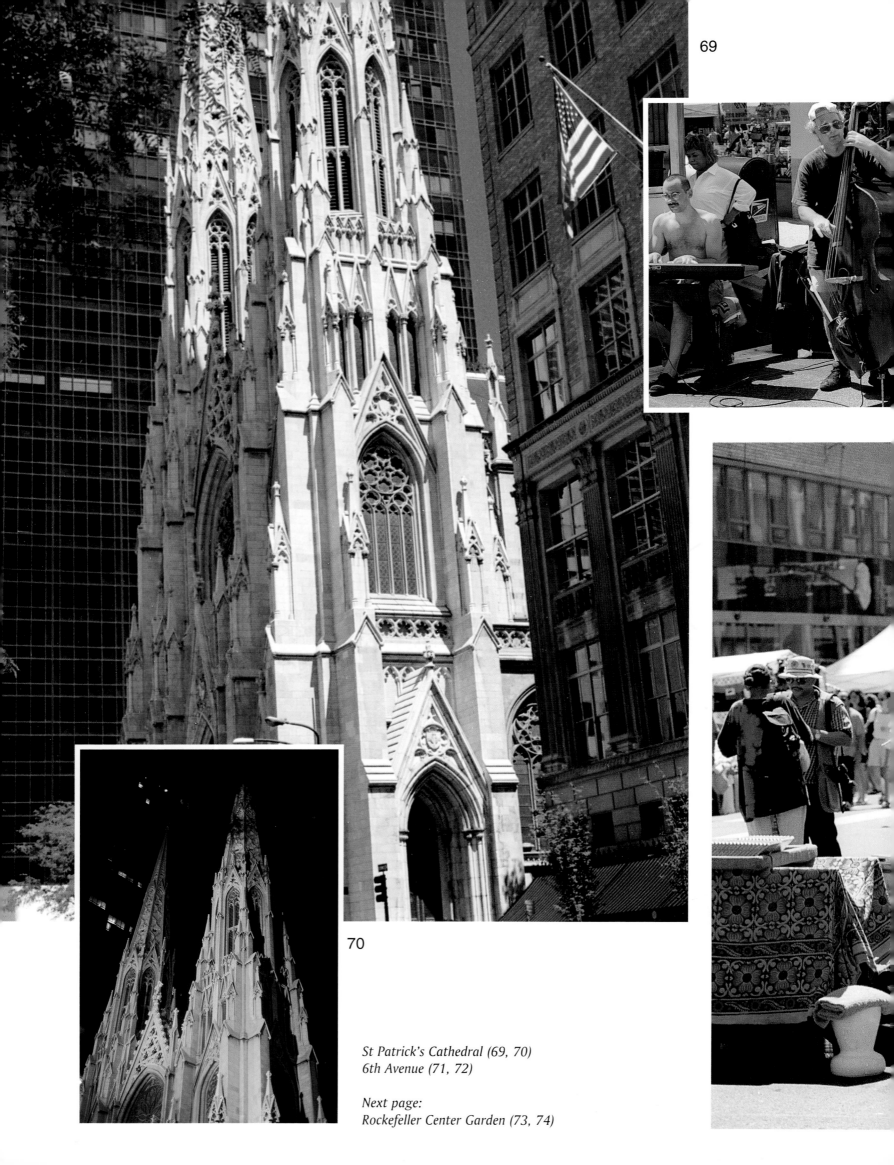

70

St Patrick's Cathedral (69, 70)
6th Avenue (71, 72)

Next page:
Rockefeller Center Garden (73, 74)

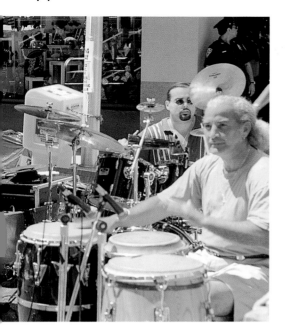

Westwards along 49th Street lies the Rockefeller Center – the first complex in the world to integrate offices with shops and entertainment. Designed and built throughout the 1930s, its mixed-use design was daringly innovative and yet based around traditional Beaux-Arts principles. The ornament of the Rainbow Room and the utter extravagance of Donald Deskey's Radio City Music Hall lobby were intended to make every cinema-goer feel like a movie star, but its sweeping staircase, sleek black smoking lounge and grand foyer also make it an Art Deco shrine.

The Museum of Modern Art, designed by Goodwin and Stone in 1939, contains one of the most comprehensive collections of modern art in the world. The bold, glass structure with its portholed canopy houses approximately 100,000 works of art and, since this was the first museum in the world to recognise design as artistic achievement, these include a silicon chip, the Bell helicopter and the kettle.

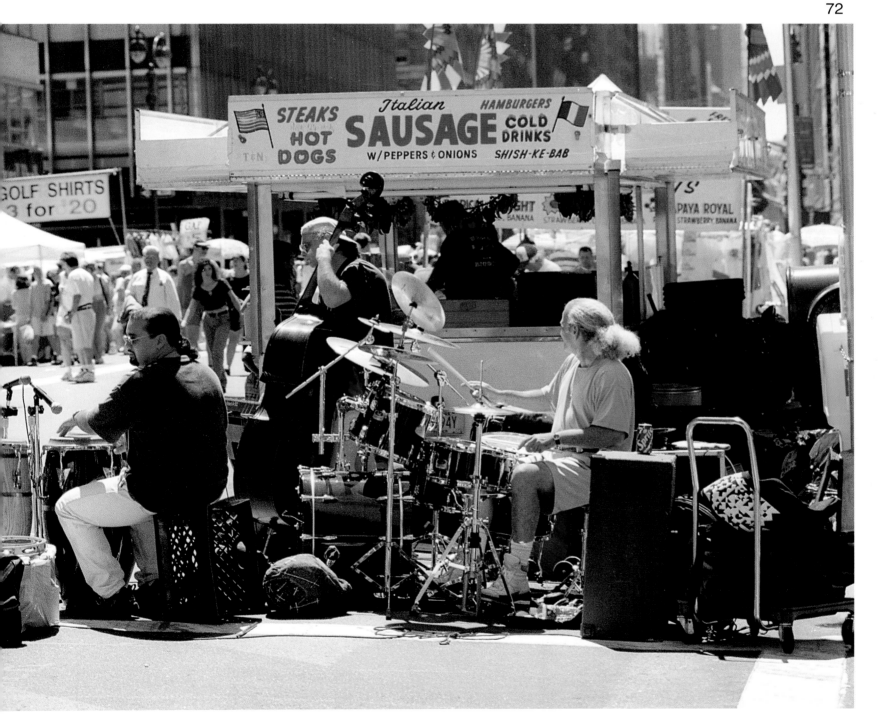

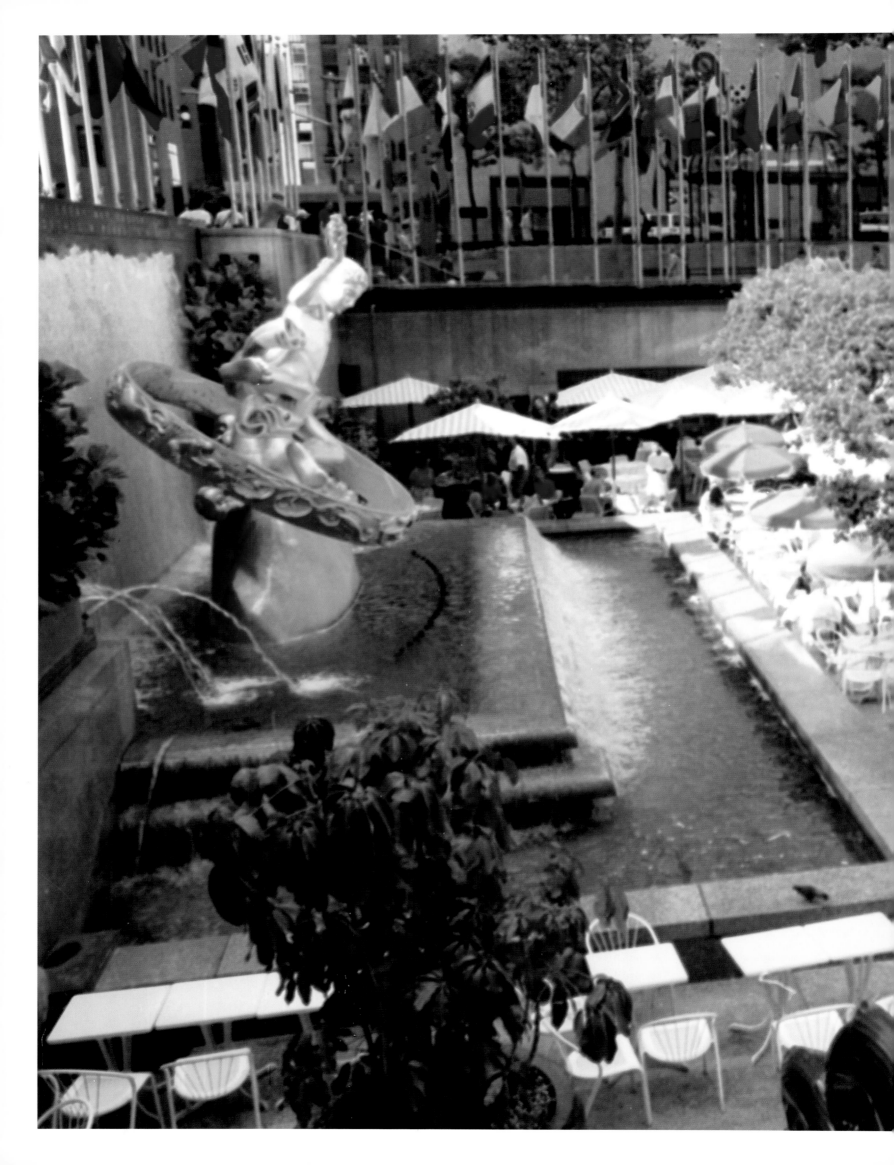

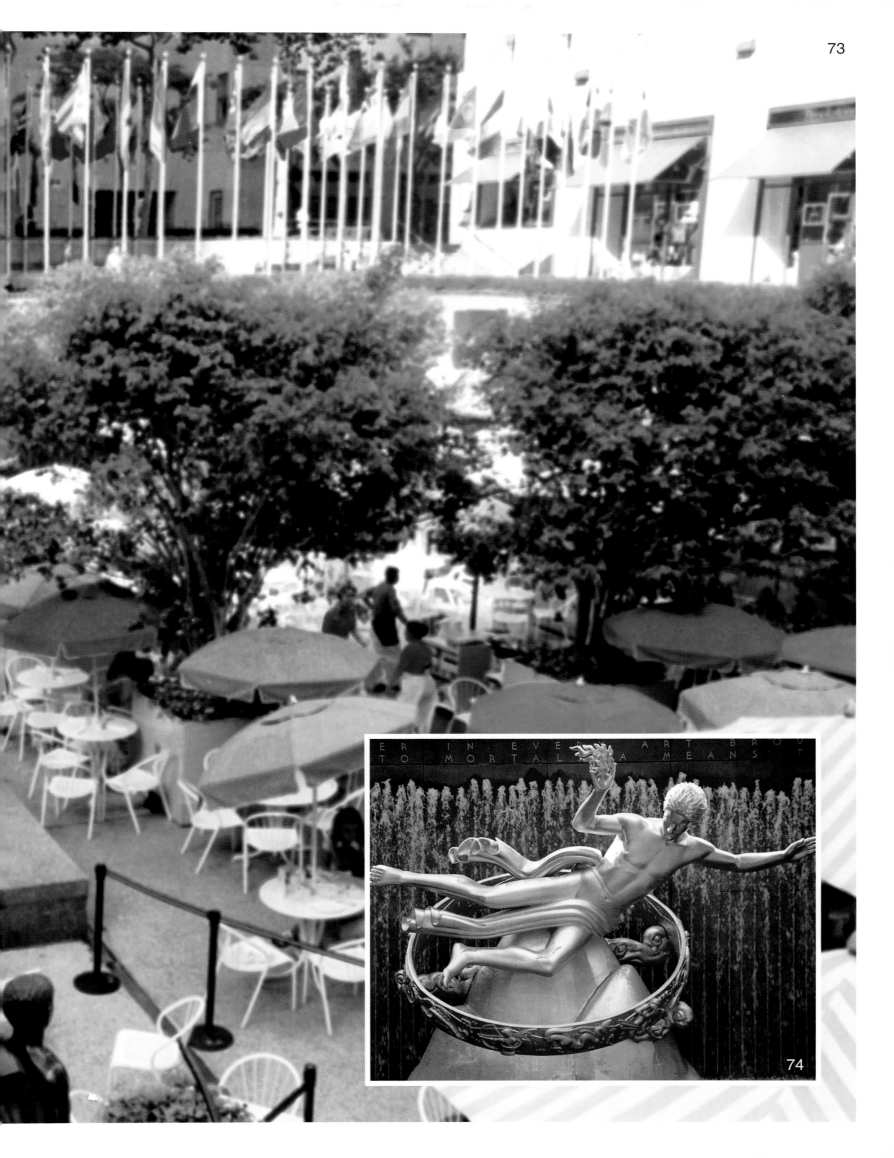

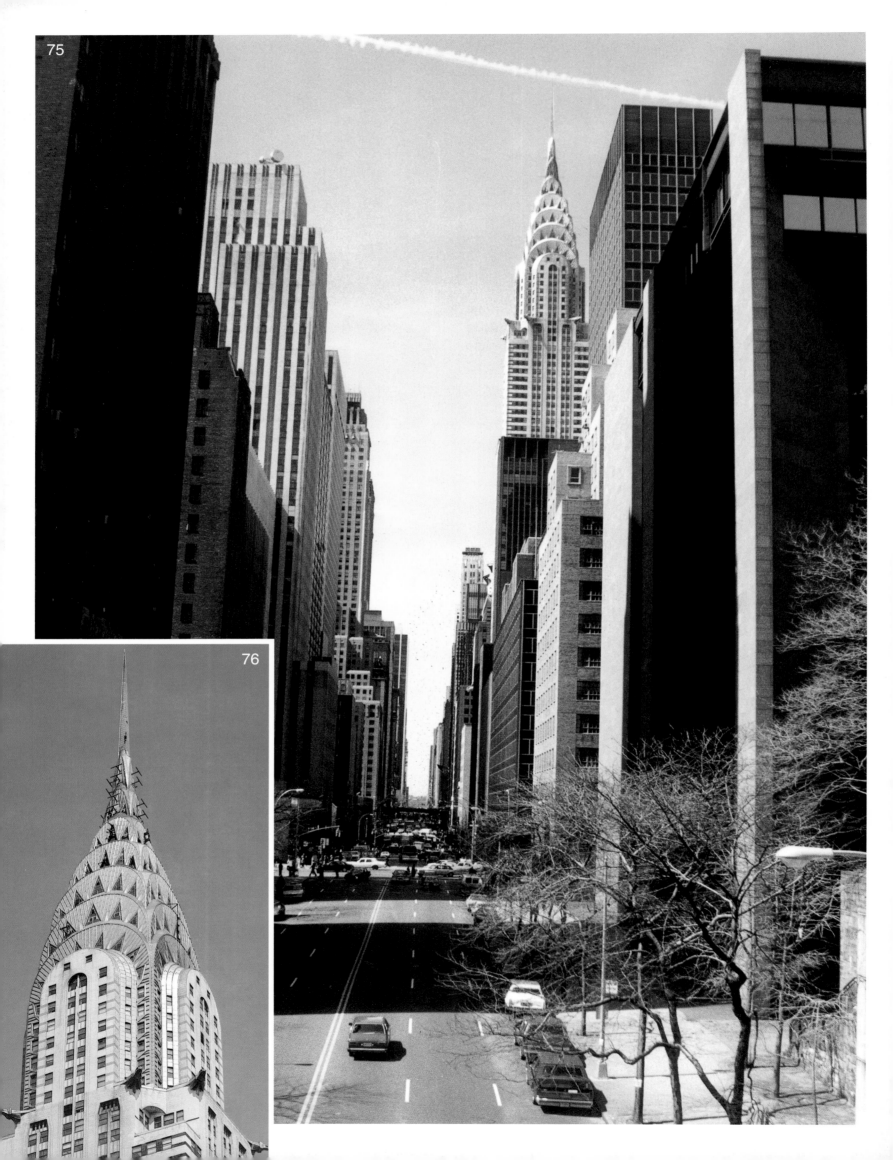

75

76

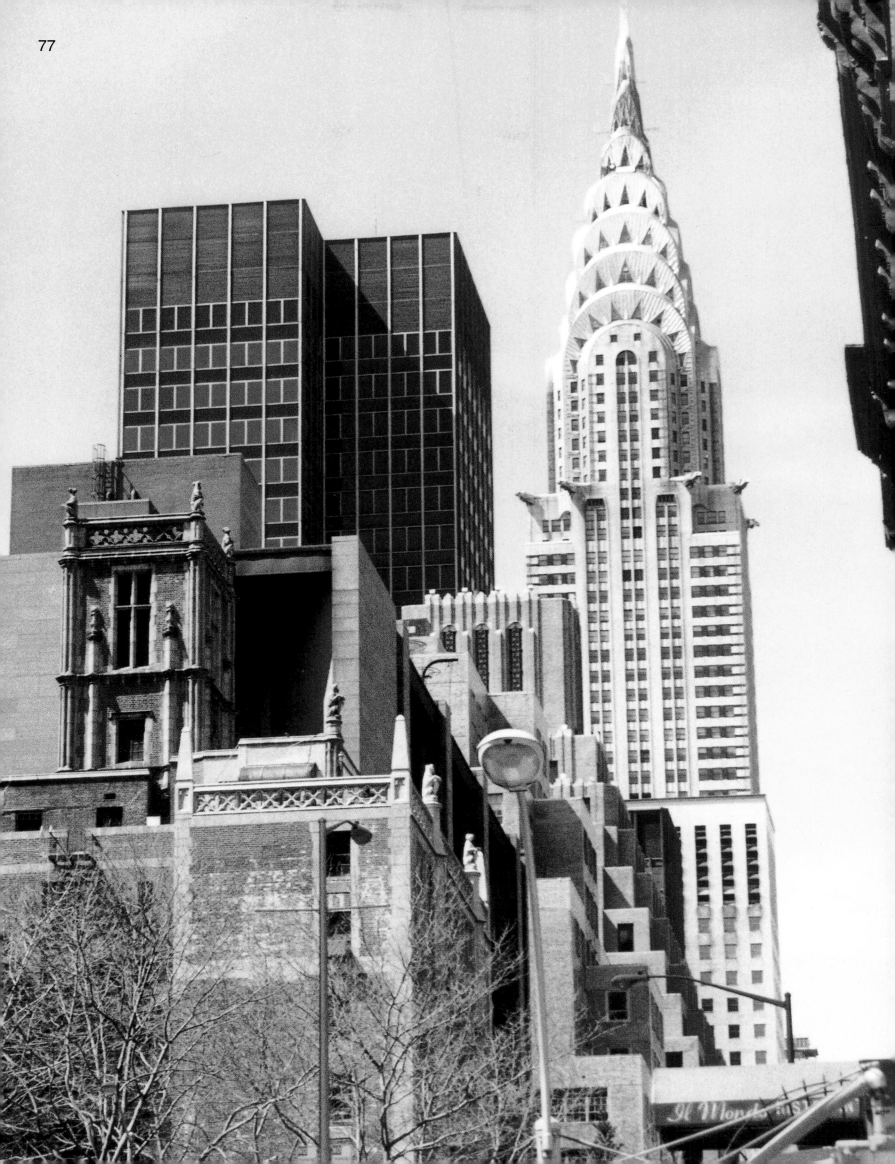

Previous page:
Views of the Chrysler Building (75, 77)
Chrysler Building (76)

View of Manhattan (78)
United Nations Headquarters (79)
New York Library on 42nd Street (80, 81)

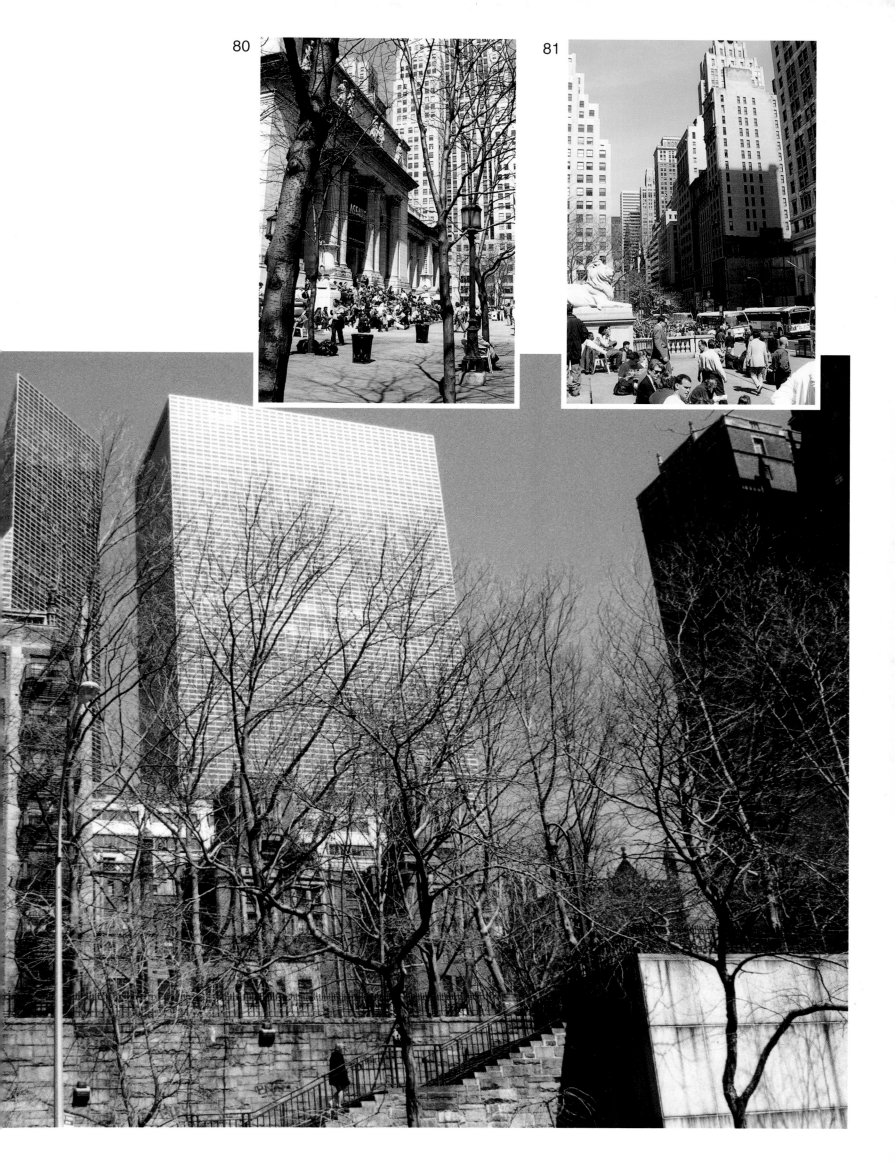

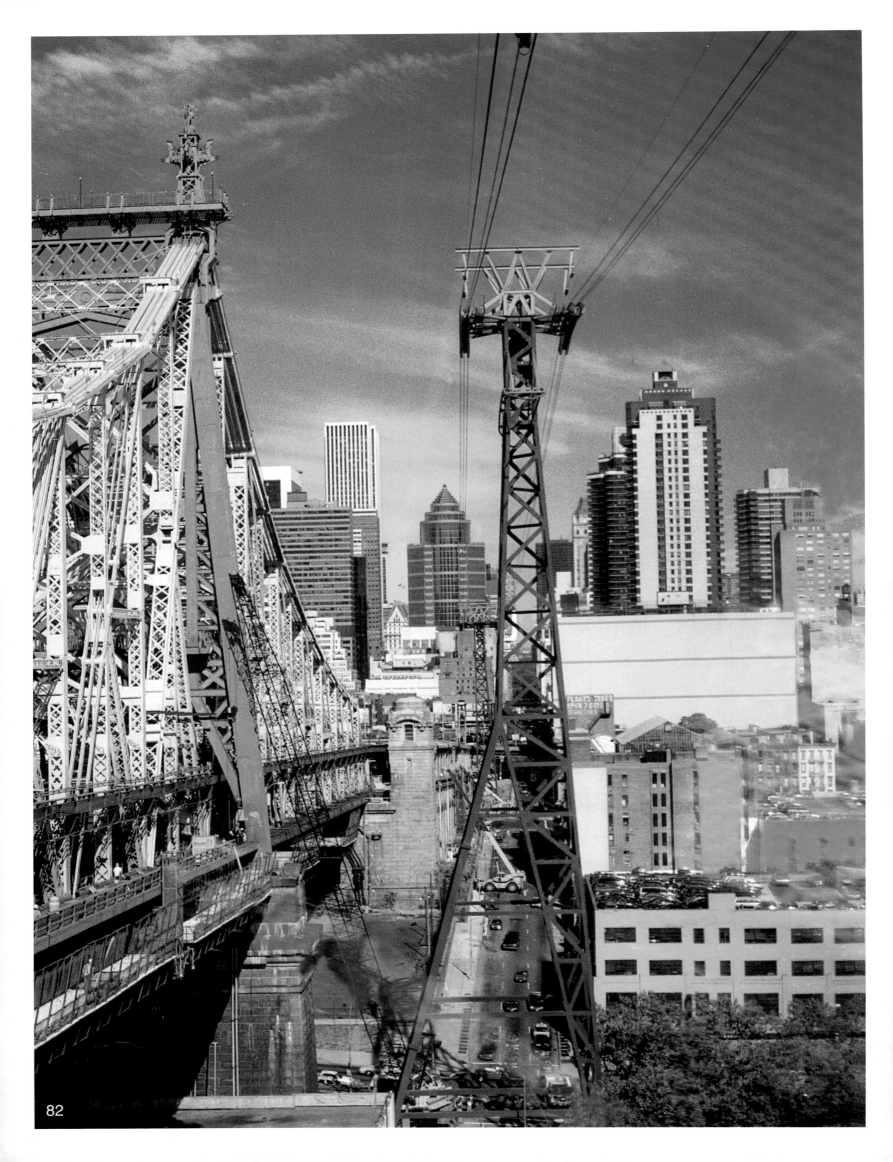

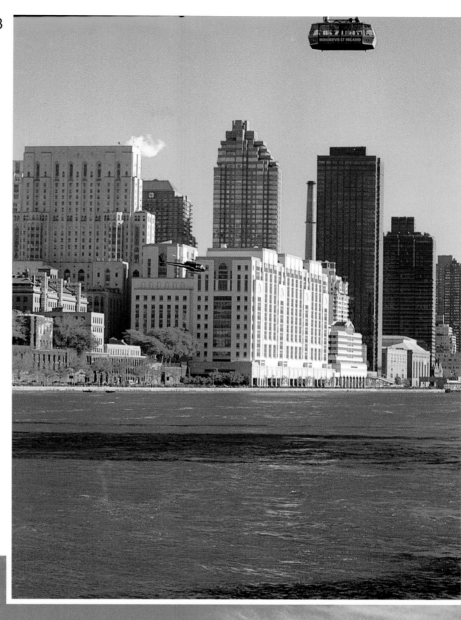

Queensborough Bridge (82, 84)
View from Queensborough Bridge (83)

Next page:
Port of Manhattan (85)
View of the Empire State Building (86)

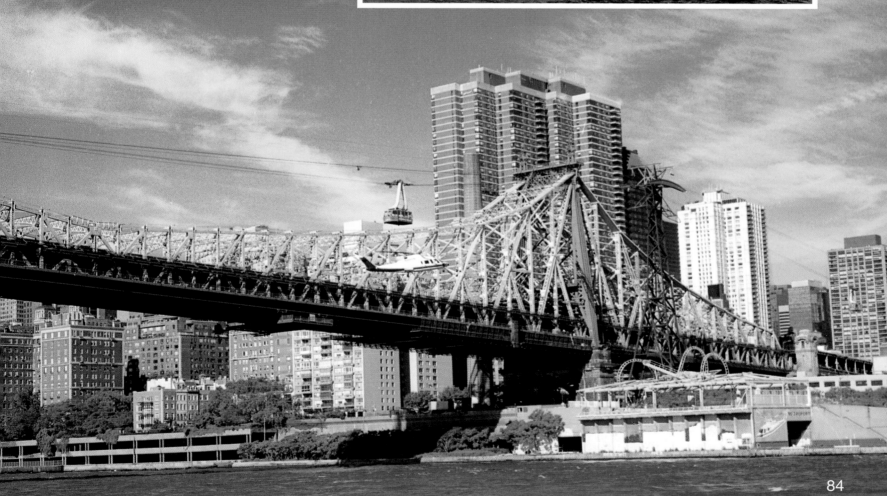

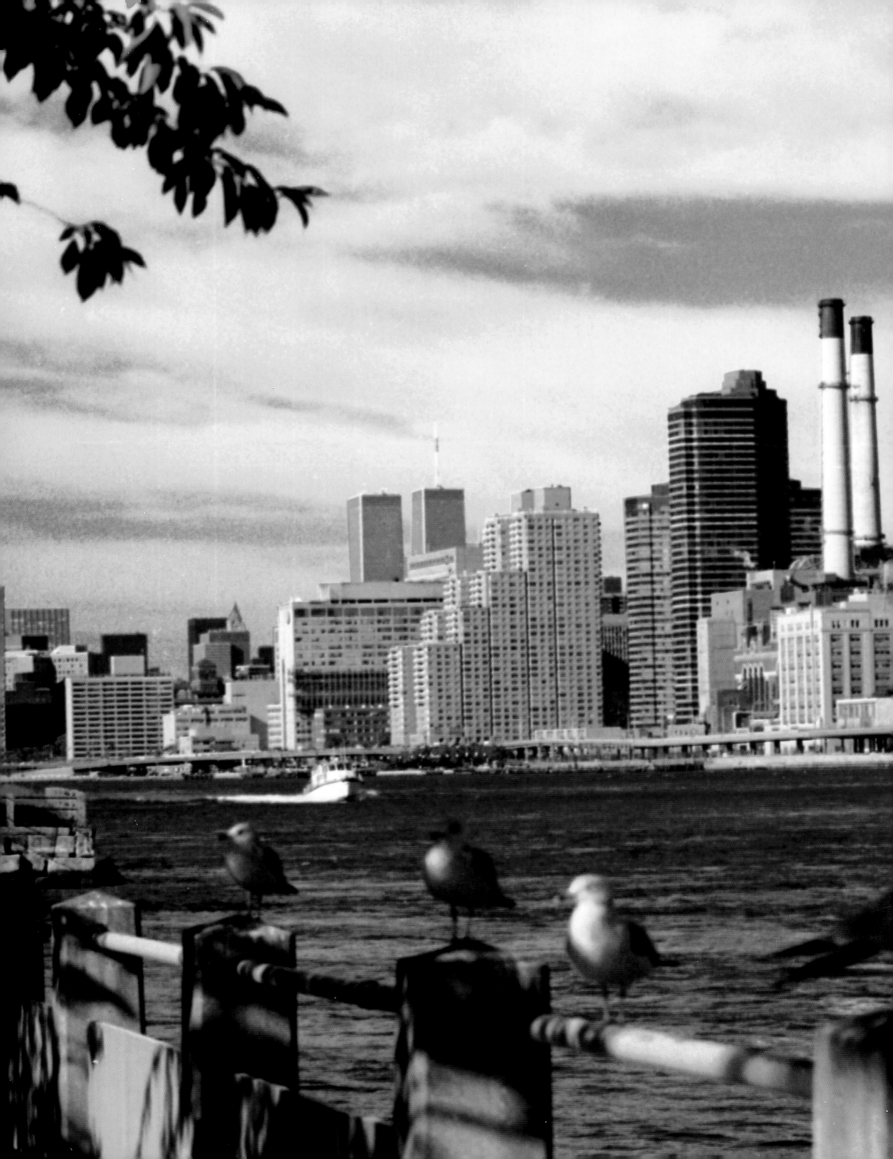

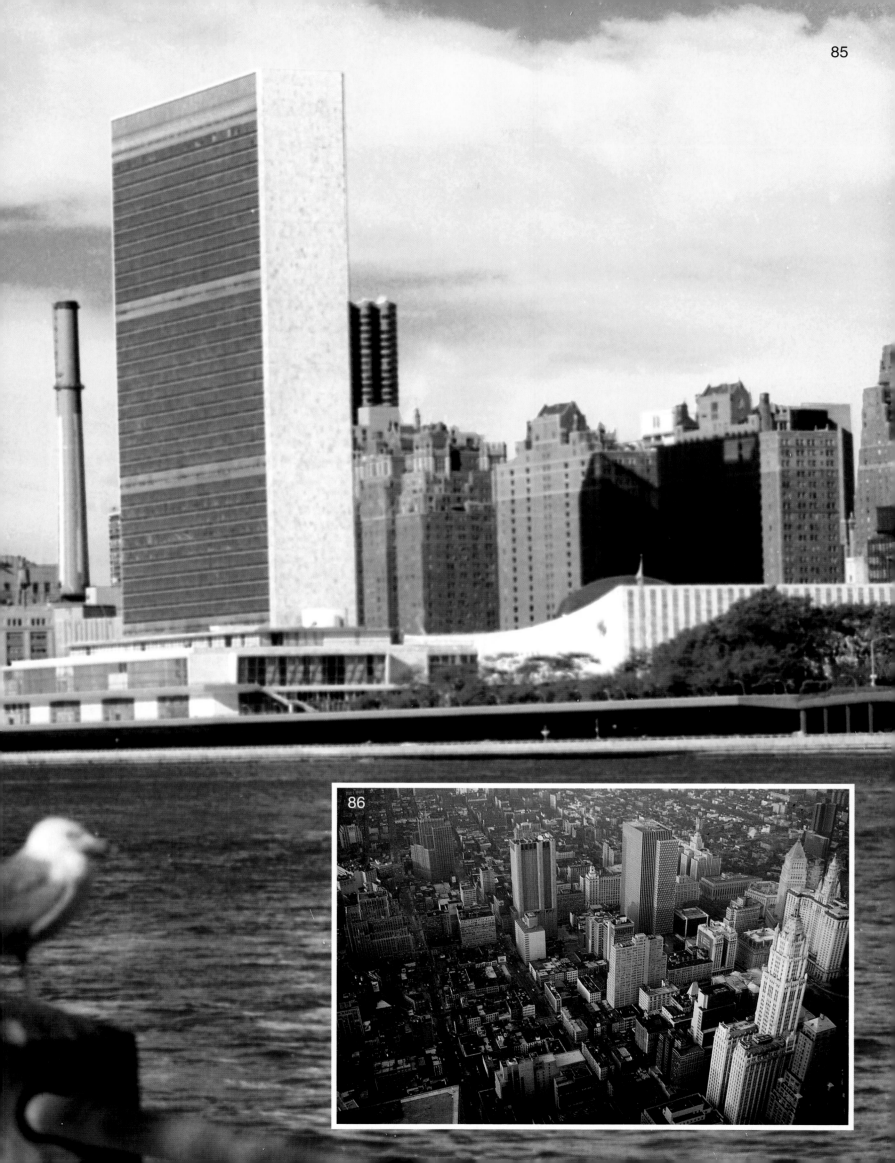

86

Upper West Side

Once Central Park was complete, smart people came flooding to the Upper West Side. Fictional residents, including Saul Bellow's Mr Sammler and J D Salinger's Glass family, all reflect the area's reputation as a serious place full of intellectual, European immigrants. In the sixties this self-image was actively promoted when the area gained its very own cultural campus in the shape of the Lincoln Center, a building undistinguished architecturally but harbouring the Metropolitan Opera House, the Avery Fisher Hall and the New York State Theater.

Central Park West is one of New York's finest streets and the ten minute stroll from West 61st Street to 72nd takes you past some of the most impressive Art Deco apartment buildings in the country. Each facade remains exactly as it was when the last of the famous twin-towered buildings (the Century at number 25) was completed in 1931. Everyone wants to live here – including Madonna, whose 'unsuitable' application was turned down by the residents' committee of number 145. Most famous of all is the Dakota – the building outside which John Lennon was shot. Sceptical New Yorkers muttered that the block was so far away from the centre of town that it might as well be in Dakota. The developers were delighted by the suggestion and immediately ordered a whole range of Wild West decorative detail. The layout is more like a group of townhouses clustered around a central courtyard than a series of apartments and the individual entrances offer almost as much privacy as a house, while it was one of the first blocks in the city to have service elevators. It also boasts Henry Hardenbergh's superb stone facades and even her husband's death was not enough to make Yoko Ono move out of one of the 65 apartments.

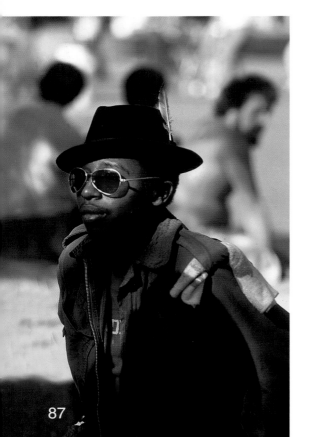

The unbelievably extravagant Dorilton, on the other hand, inspired a contemporary critic to write that 'the sight of it makes weak women shrink affrighted'. It provides a striking contrast to the more muted Ansonia, just two blocks away. Here, among the ornament and the balconies, lived Enrico Caruso, looking out from his roof garden onto the central focus of the entire area – the Park.

88

A visitor of Central Park (87)
Lake in Central Park (88)
Central Park entrance (89)

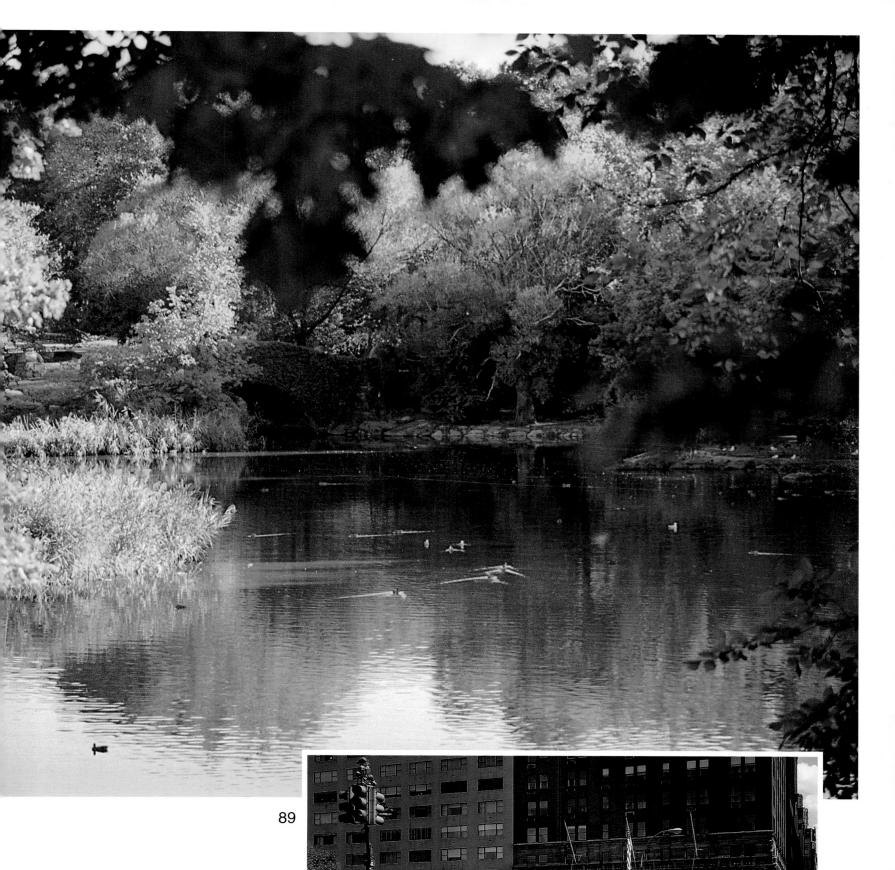

89

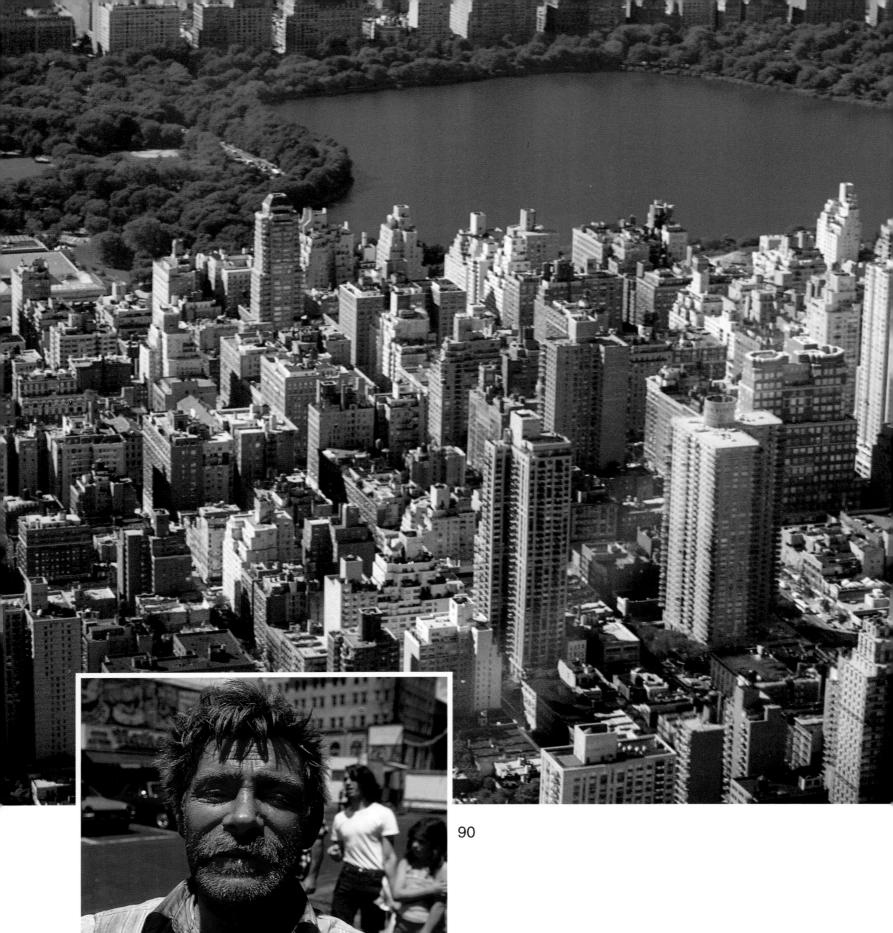

90

Central park (90–92)

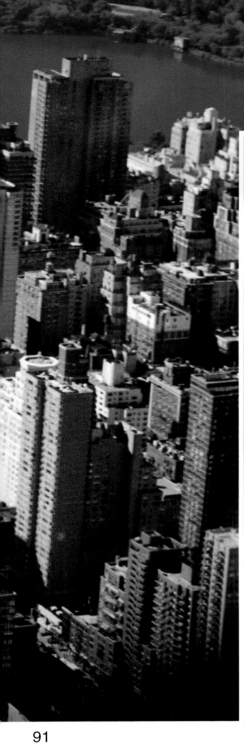

91

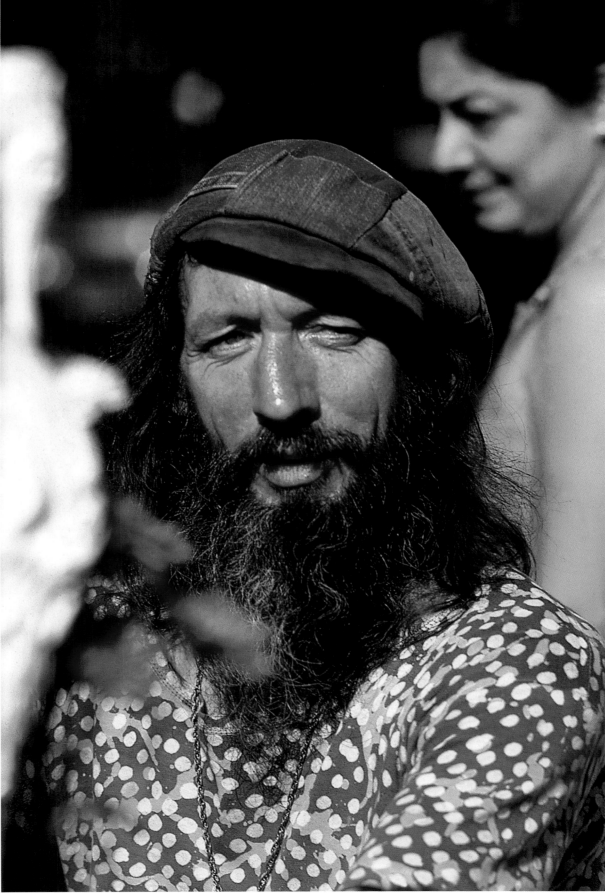

92

Central Park

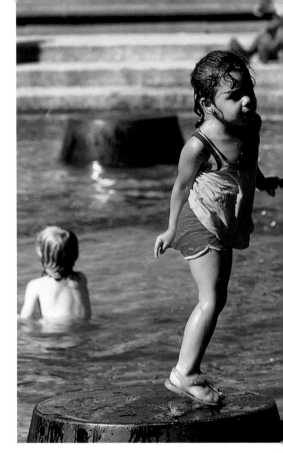

Frederick Law Olmsted's 843-acre idea was to create a democratic place with 'each individual adding by his mere presence to the pleasure of all others'. He was convinced that the urban environment had an oppressive effect on most of its dwellers and he sought to find a solution to the harshness of city life.

In 1853, after years of public haggling, the state legislature paid $5.5 million to acquire the land which had, until then, been pig farms and shanty dwellings. Olmsted was on the staff of the City Council when the design competition was held and he joined up with Calvert Vaux to prepare a scheme called 'Greensward'. The amazing range of landscape experiences which the pair created within a single area easily won first prize. Now the park is living proof of their thesis, welcoming everyone from teenage joggers to geriatric ice-skaters and, although Olmsted and Vaux fought to prevent views of the city impinging on the park, snatched glimpses of the Dakota and the Guggenheim are the stuff that films are made of.

94

93

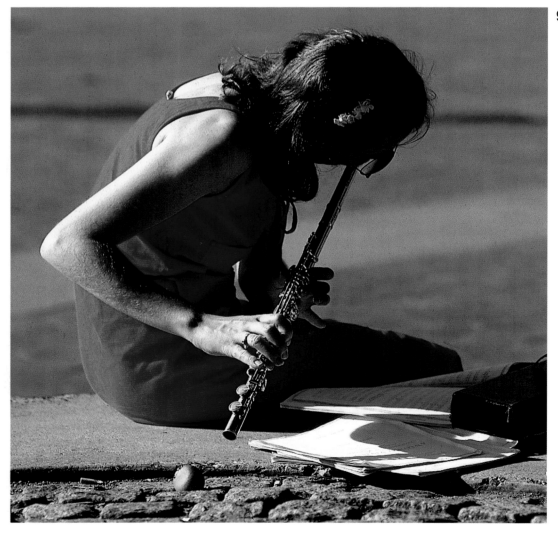

Young woman playing the flute in Central Park (93)
Children in Central Park (94)
Central Park (95, 96)

Next page:
Central Park in winter (97)

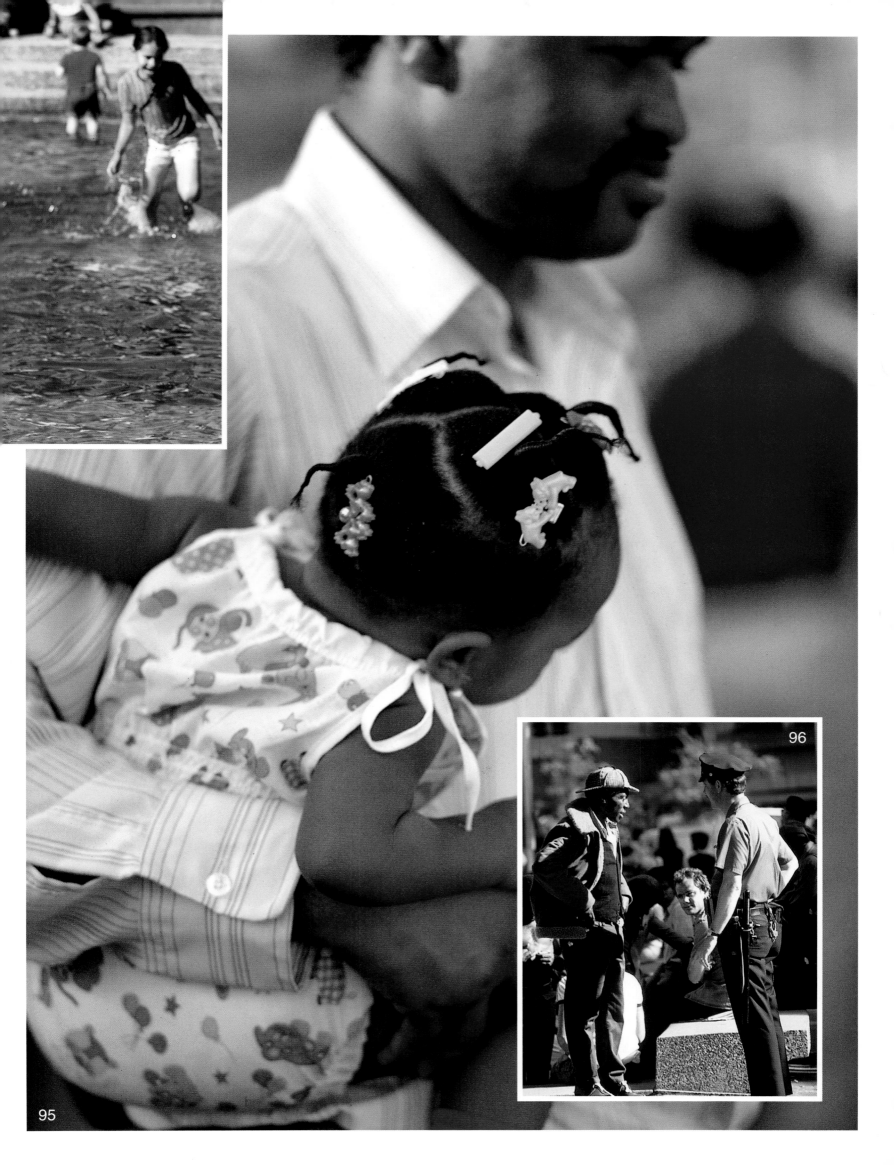

95

96

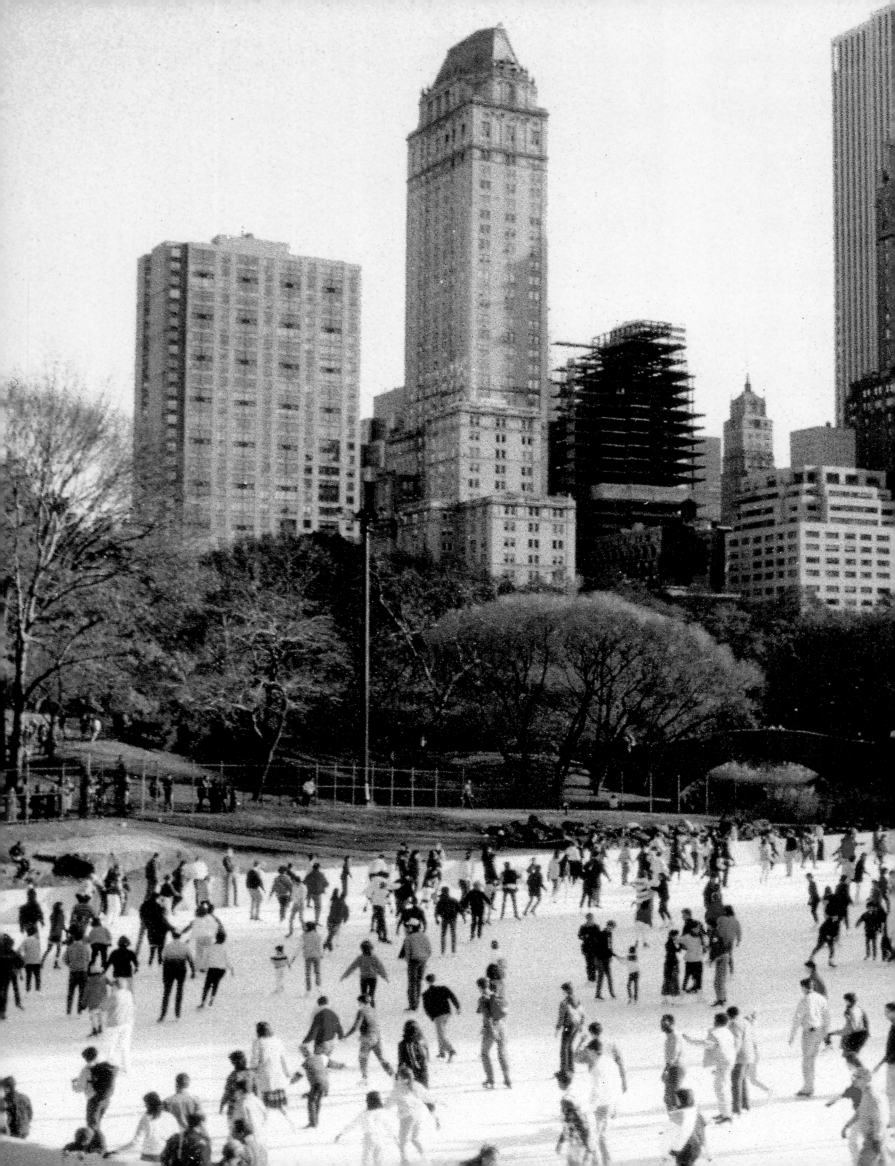

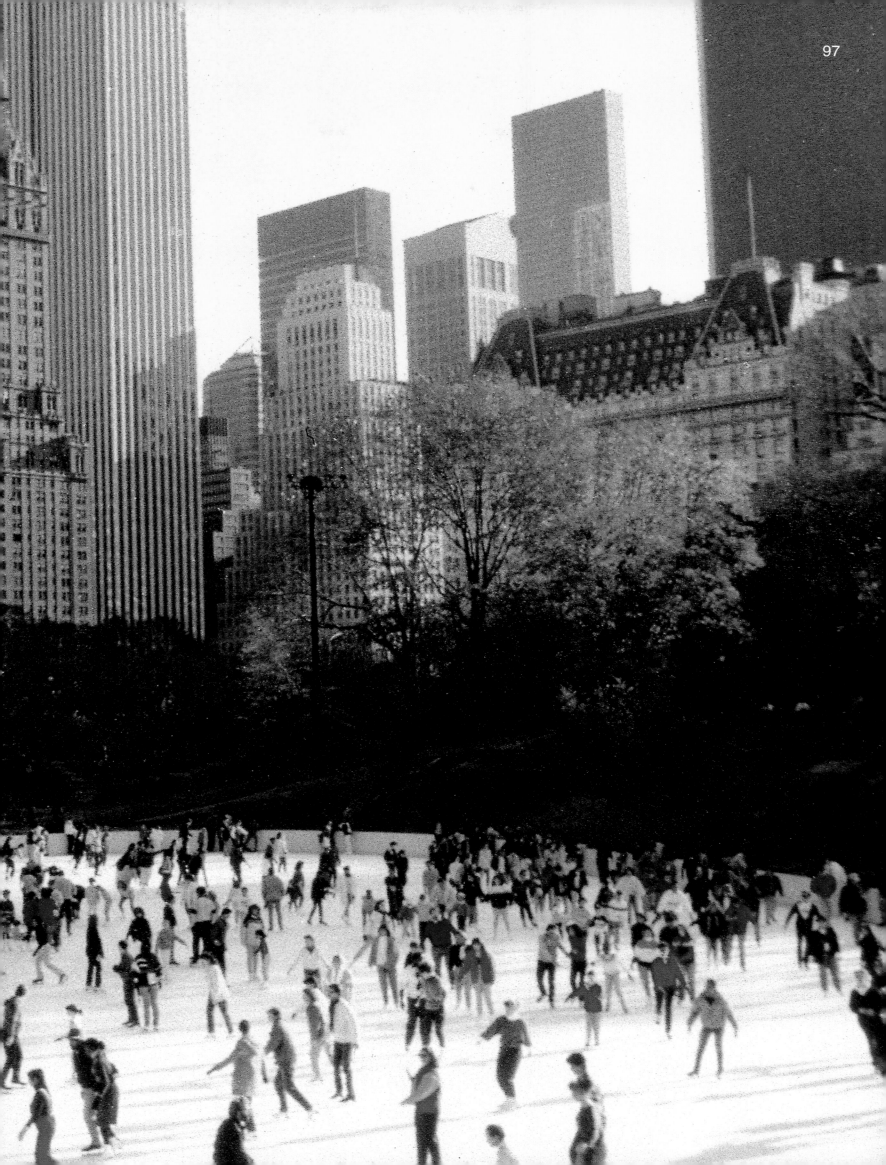

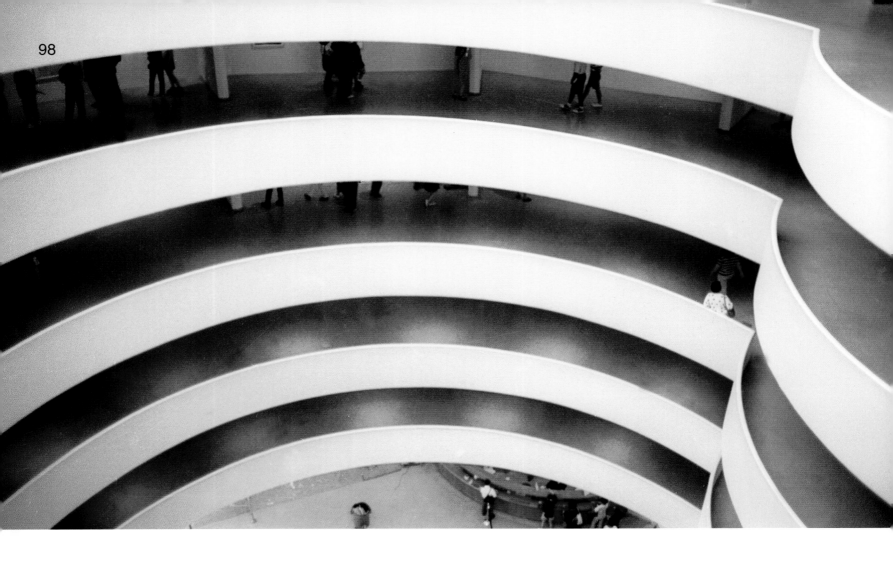

Upper East Side

The Upper East Side means museums and money. The great invasion began in the 1890s when commercial interests began buying up midtown property and Mrs Astor and her cronies beat a horrified retreat to Millionaires' Row, the stretch of Fifth Avenue bordering on the newly built Central Park. The Solomon R Guggenheim Museum looks totally out of place in such prim surroundings – an effect that must surely have been half the fun for its creator, Frank Lloyd Wright.

In 1927 Solomon Guggenheim, a mining magnate, commissioned a portrait from a dynamic woman called Baroness Hilla Rebay von Ehrenwiesen. She was mad about abstract art and promptly introduced him to her buddies – Kandinsky, Leger and Klee. She then suggested the ultra-modernist Lloyd Wright as the architect for a suitable showcase for Guggenheim's now considerable modern collection. The 1959 building, with its famous spiral staircase and its bright, white ramp, became Wright's only New York contract but, by the time it was finished, both architect and benefactor were dead.

The Metropolitan Museum, on the other hand, is New York's palace of establishment culture. Calvert Vaux's 1880 Gothic facade is now barely

Guggenheim Museum
(inside view) (98)
Guggenheim Museum
(outside view) (99)

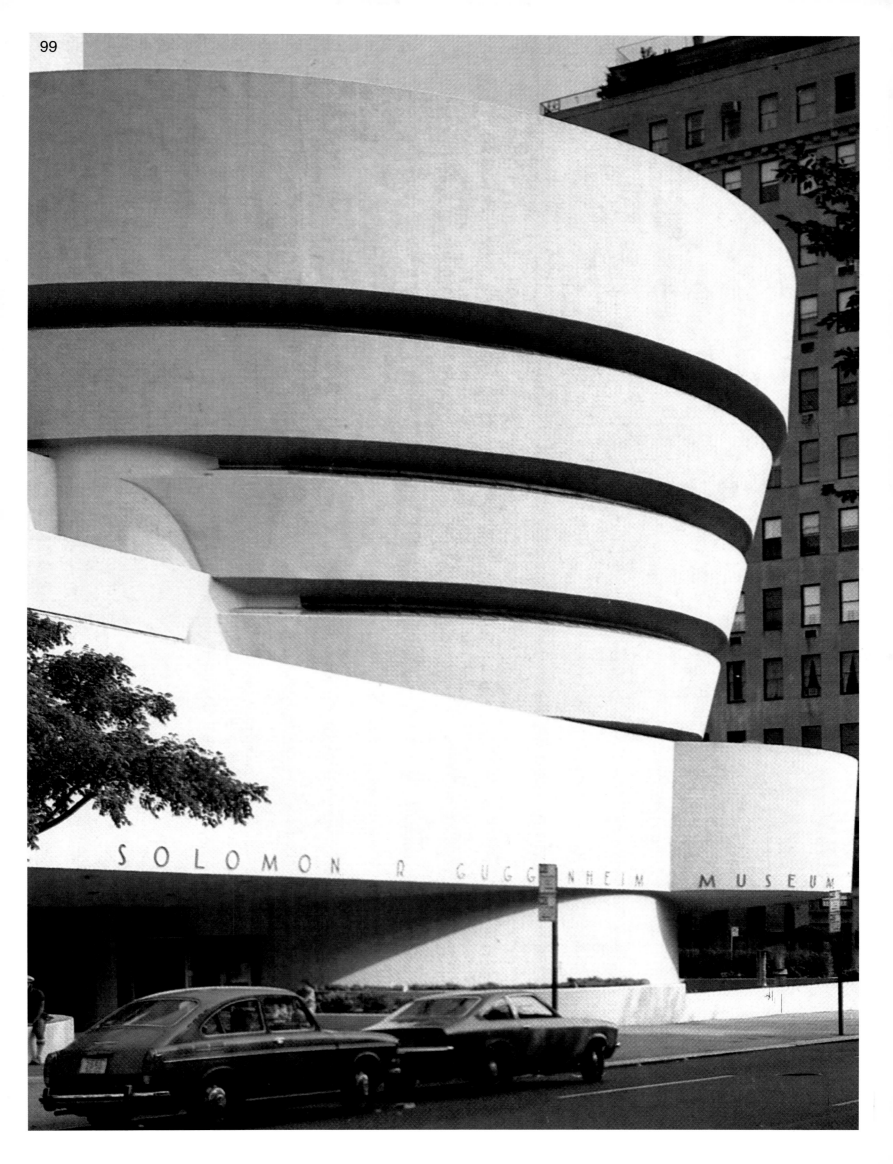

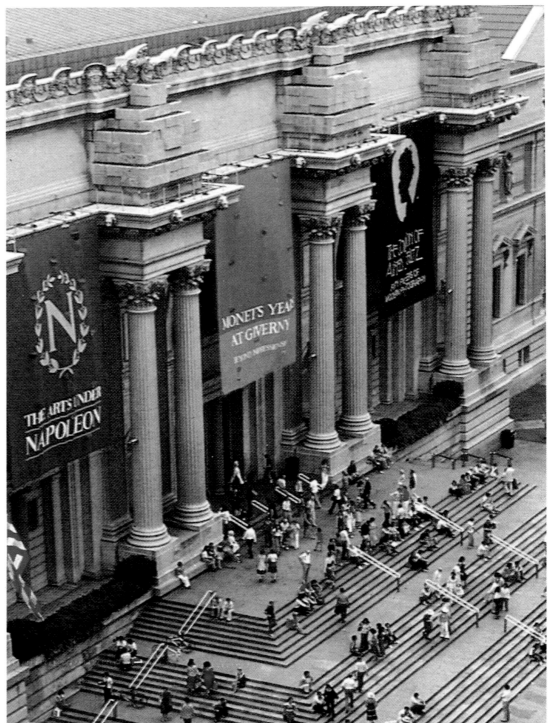

101

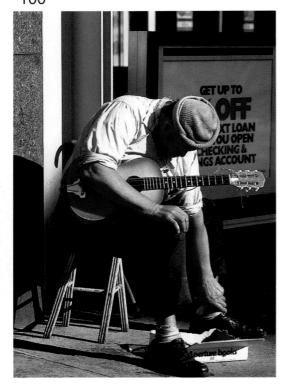

100

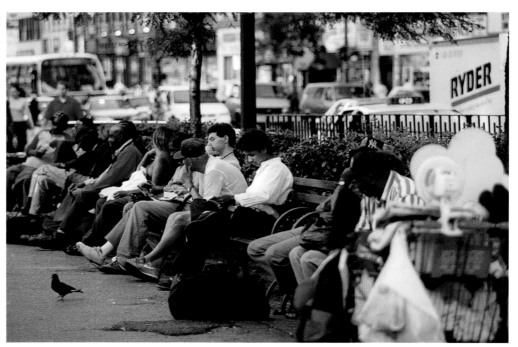

102

Metropolitan Museum (101, 103)
Daily life around Upper
East Side (100, 104)

visible behind the Beaux-Arts frontage added by Richard Morris Hunt in 1902 but the galleries are still arranged chronologically and span 36 centuries, with the most extraordinary exhibit being the first century Temple of Dendur which was transported complete from Egypt in 1960. This grand celebration of antiquity could not be more different from the inverted modern pyramid that is the Whitney Museum of American Art. With its deliberately skewed window, it was opened in 1966 in order to contain Ms Whitney's amazing showcase of modern American art after the Metropolitan Museum of Art turned it down.

Local psychiatrists apparently send their patients to relax at the Frick since this limestone mansion, designed in 1914 by Carrere and Hastings, is a haven of peace which admits only 200 visitors at a time.

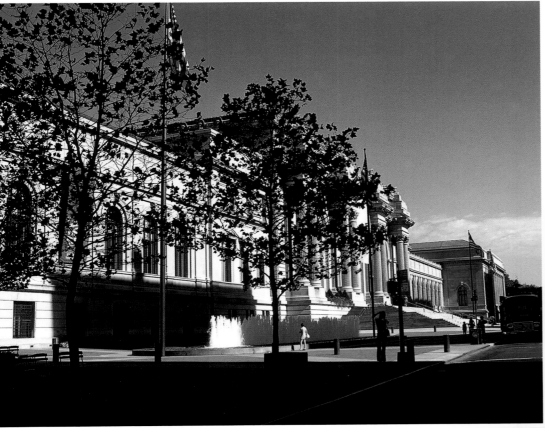

103

104

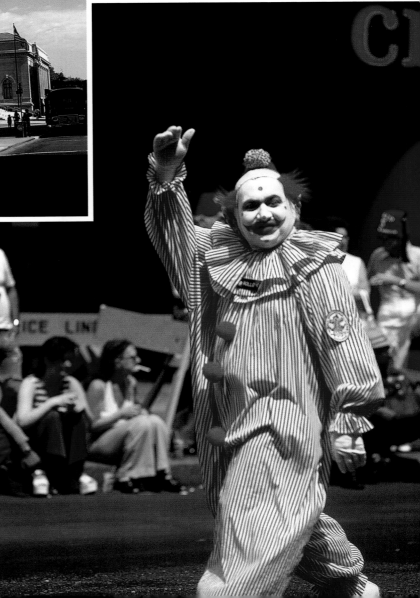

Henry Clay Frick made his millions out of steel and low pay and, in 1892, conditions in his mill were so appalling that the workers staged a five-day sit-in during which fourteen people were killed. Frick could block out these events sitting in his courtyard, staring at the fountain, and contemplating his passion for European Old Masters, French furniture and Oriental rugs.

Harlem and the Bronx

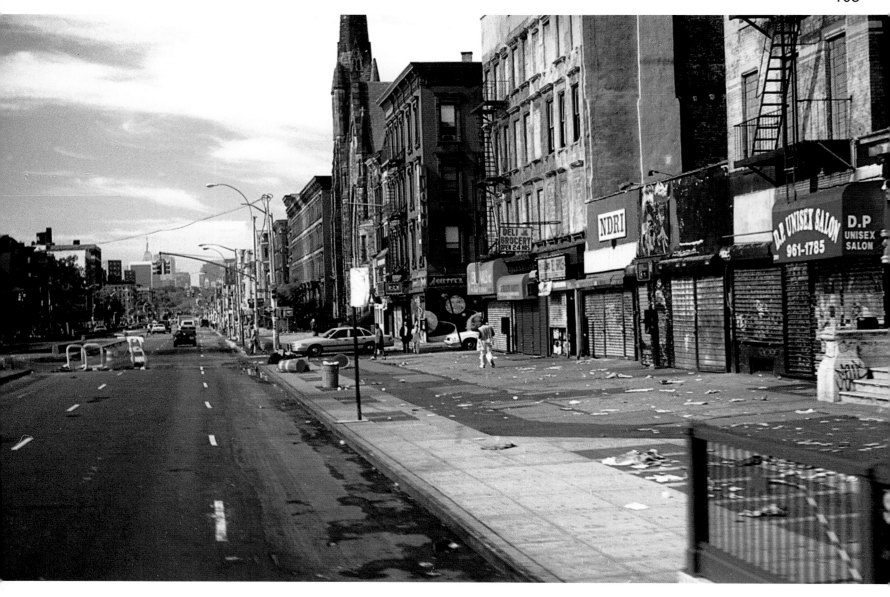

Streets in Harlem and the Bronx (105, 106)

When a new subway line to the north of the city was proposed in 1904, building speculators flooded in. Unfortunately for them, the desired middle-class tenants did not, and so a black real-estate agent called Philip A Payton filled the empty buildings with black tenants, often at higher rents than the whites. Between 1920 and 1939, the population doubled to over 200,000 during which time its poets, writers and musicians ushered in the Harlem Renaissance – a celebration of black culture which was, for the most part, enjoyed by an exclusively white audience at such local venues as the Cotton Club.

During the Depression, unemployment here was twice that of the rest of the city and this marked the beginning of the area's economic decline. Social conditions deteriorated after the Second World War when over a million black people moved into the area, but deprivation led to politicisation and, by the sixties, Harlem was America's centre of black consciousness. While it now houses the Schomburg Center of Research in Black Culture, a rather more symbolic landmark is the former Lenox Casino which, in 1965, metamorphosed into Masjid Malcolm Shabazz – the ornately decorated

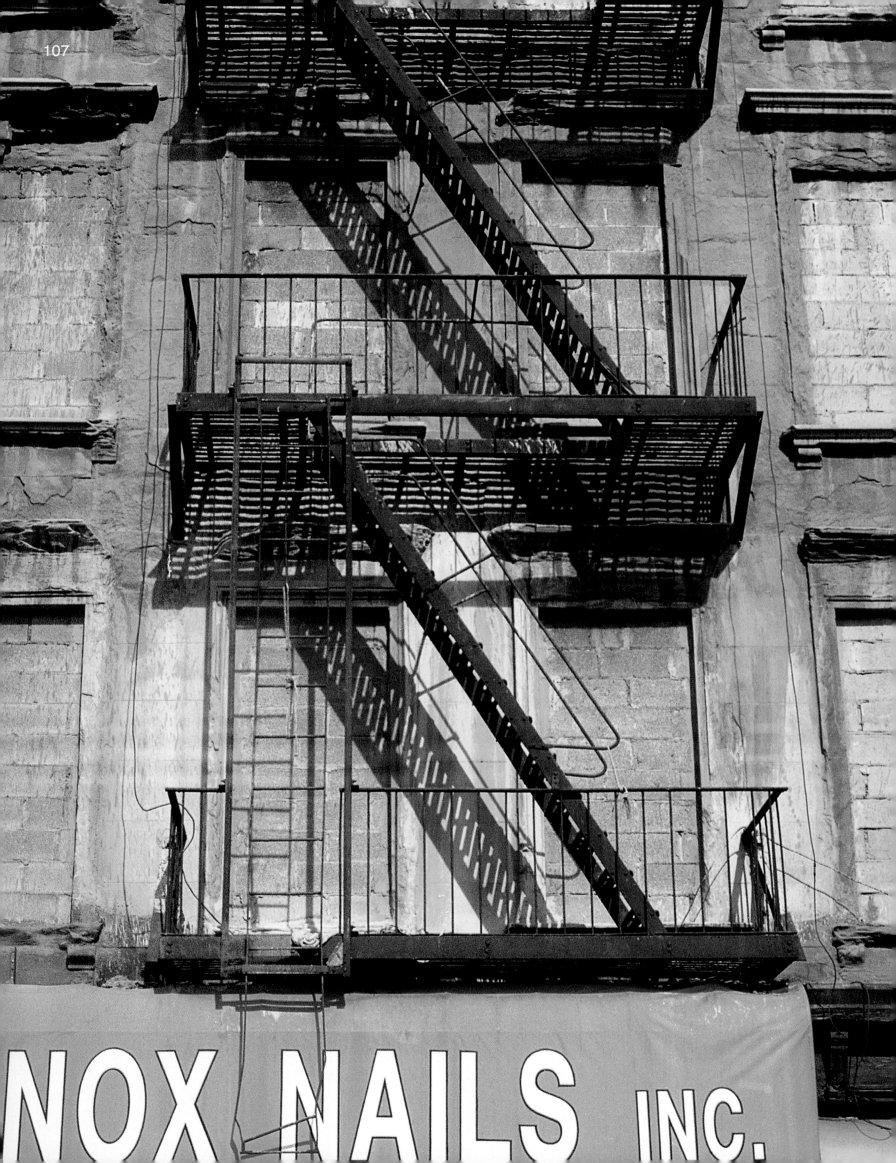

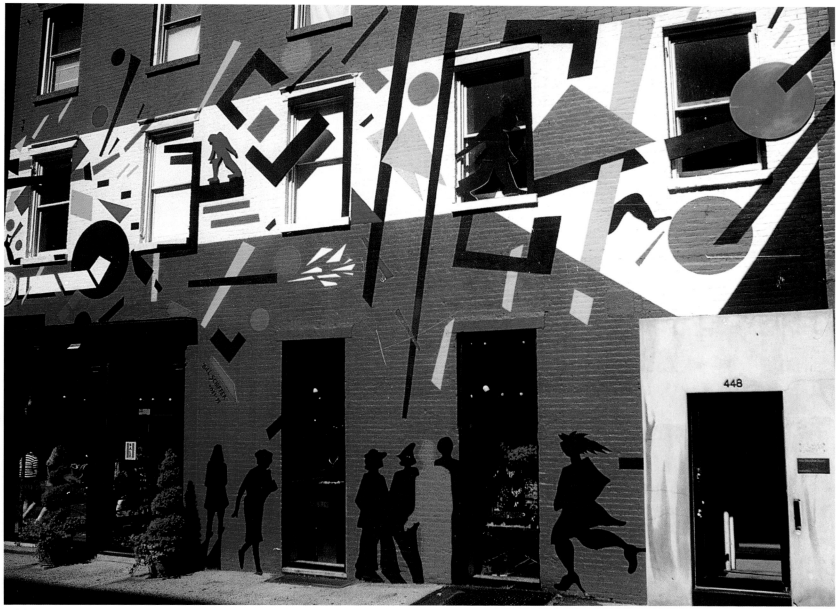

108

Fire escape in Harlem (107)
Colourful facade in Harlem (108)

Next page:
Facades in Harlem (109, 110)

mosque which serves as the ministry for the community of Malcolm X. 125th Street, however, is still Harlem's main thoroughfare and its best known building is the Apollo Theater – launching pad for the careers of such jazz luminaries as Duke Ellington, Billie Holiday and Lena Horne. By 1976, it had decayed beyond redemption and was closed down but, after much public protest, it was renovated and, eventually, reopened as a recording studio.

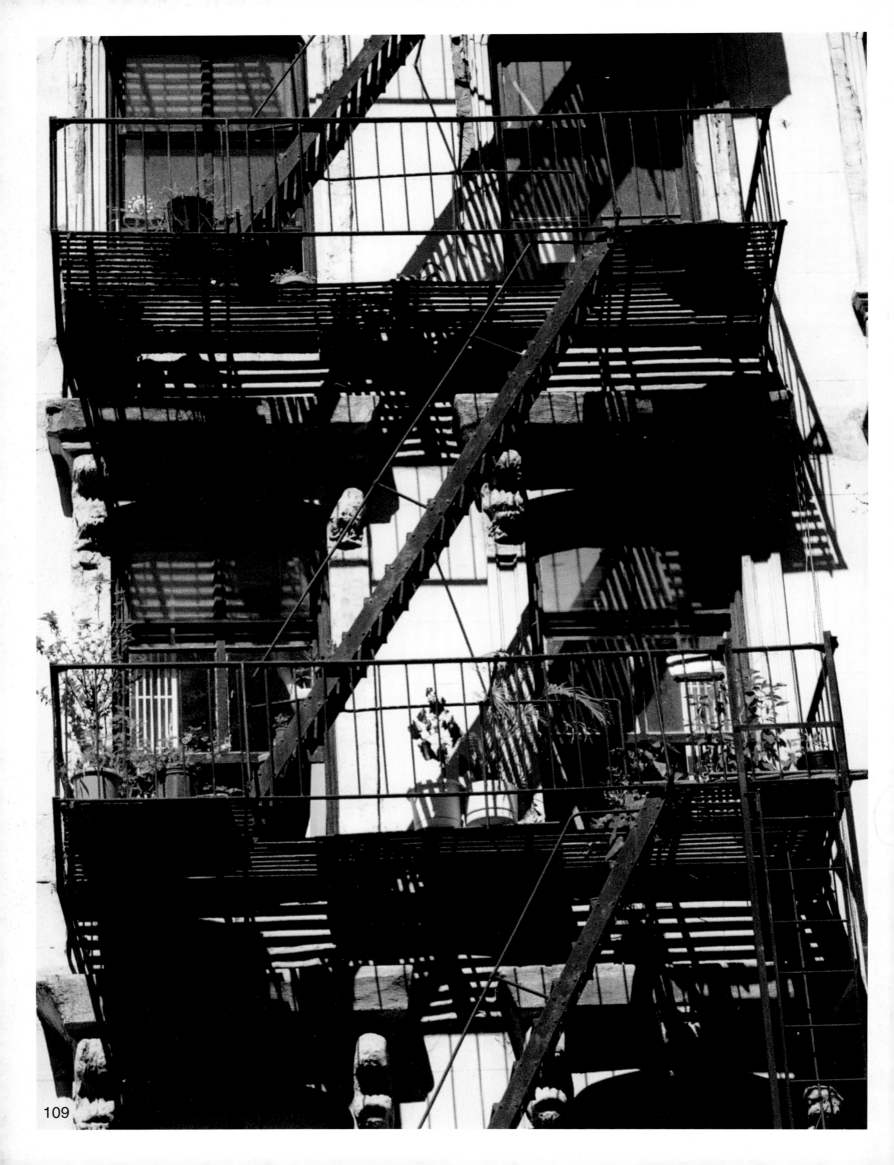

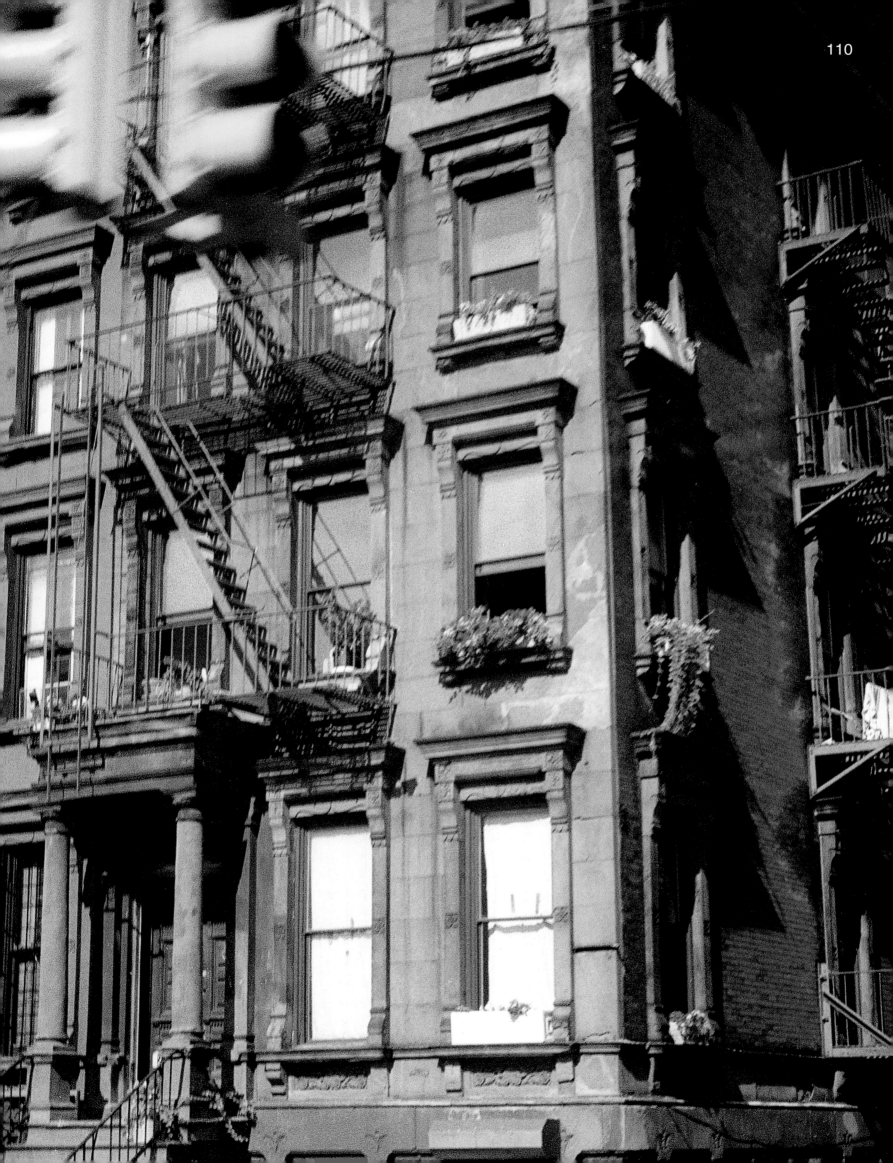

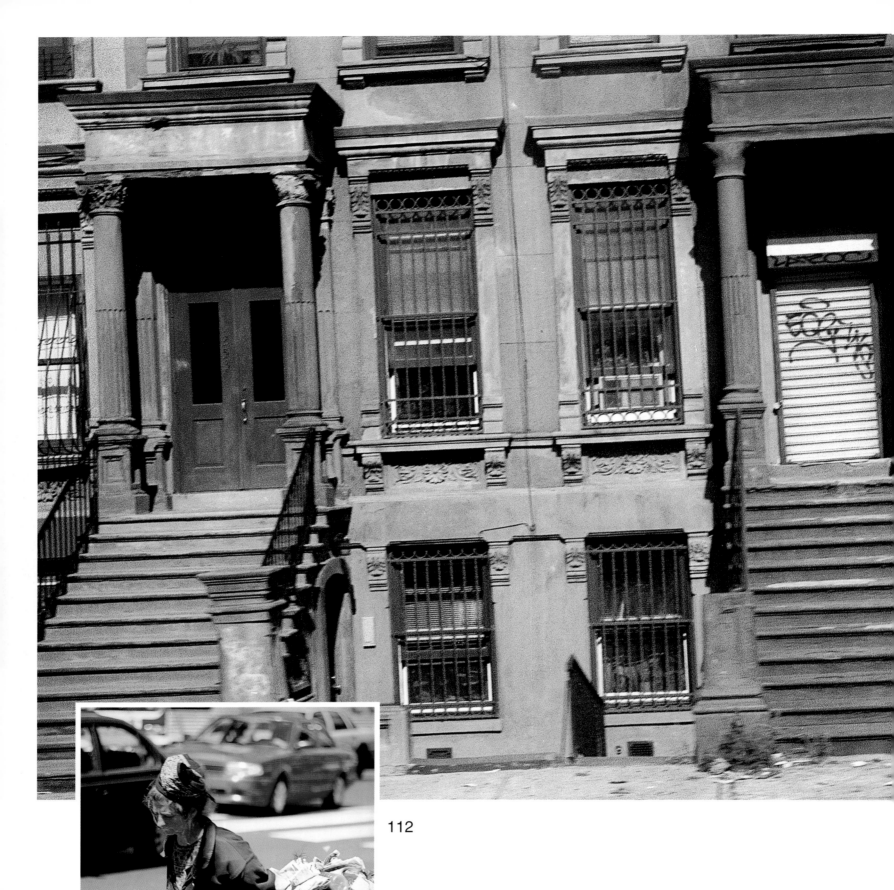

112

Daily life in Harlem (111–113)

Next page:
Streets in Harlem (114, 115)

The Bronx

The Bronx acquired its name in 1641, when Jonas Bronck purchased 500 acres of local land from the Dutch West India Company and built a farm here.

111

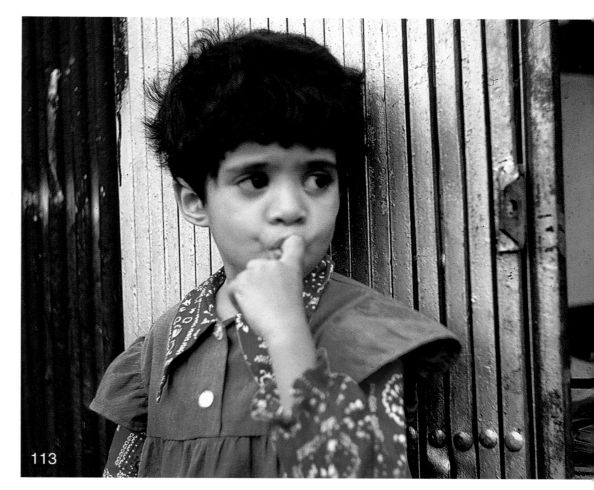

113

Once a rural idyll, the invention of the automobile meant that everyone who wanted to live out of the city could now go much further, much faster and the Cross-Bronx Expressway, constructed in the fifties, spelt the end for the area. Commuters fled to the suburbs and the Bronx was abandoned to decay and insurance fraud – in 1975 alone there were 13,000 fires.

Though the Grand Concourse, which was built in the twenties, is still lined with spectacular, though decaying, Art Deco apartment buildings, the two main reasons to visit these days are the Yankee Stadium, home of New York's baseball team, and the Bronx Zoo, which is the largest urban zoo in the US. Visitors zoom through 'natural habitats' on a mono-rail and regularly experience virtual thunderstorms in the reptile house. The South Bronx, meanwhile, though the birthplace of hip-hop, is not somewhere you would choose to visit even on a mono-rail. Still burnt-out and decayed, it is now also dangerous and ugly.

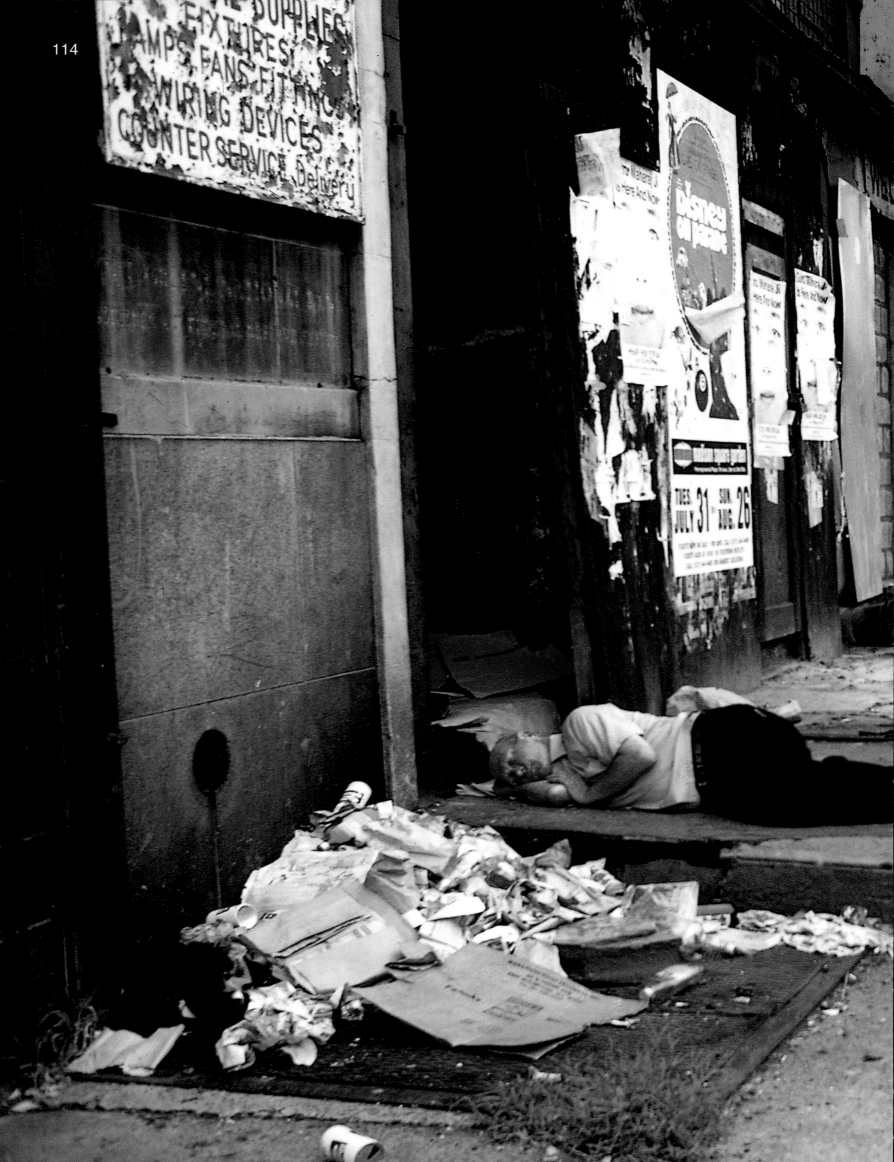

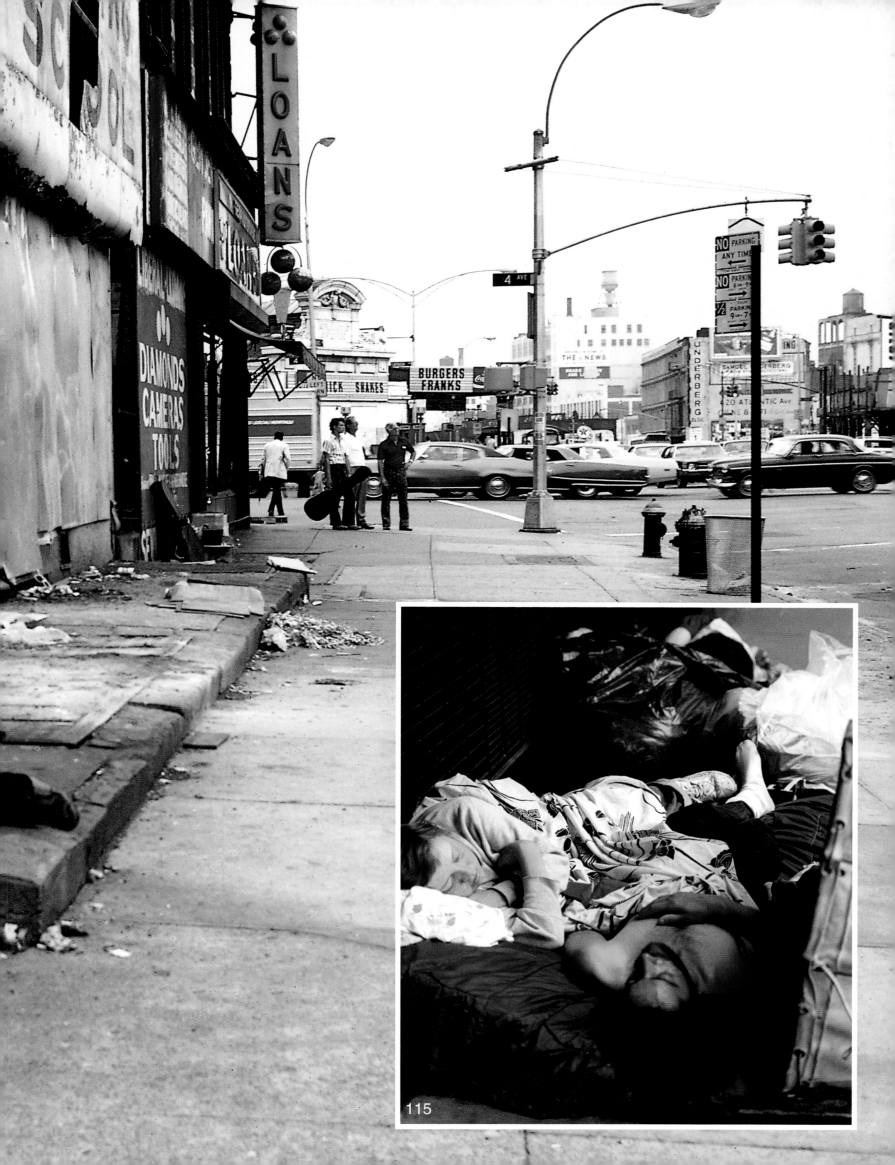

Brooklyn and Coney Island

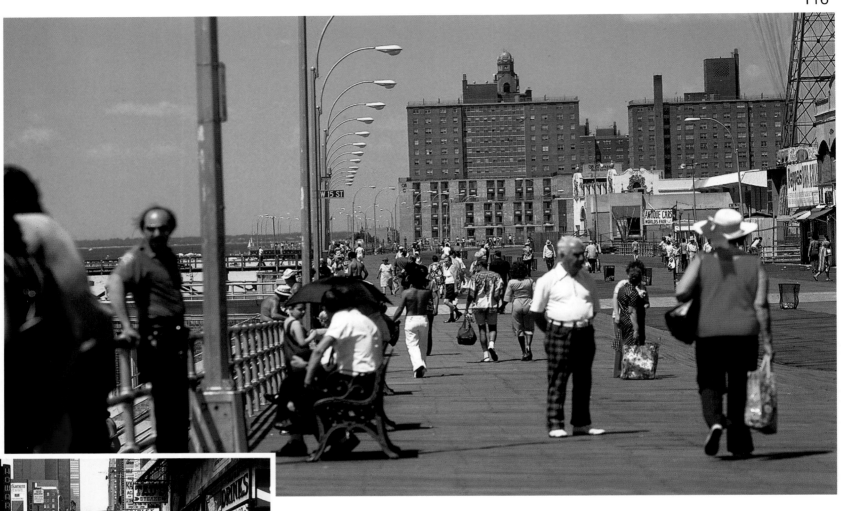

After the first ferry service to Manhattan was started in 1814, landowners began developing Brooklyn in earnest and, by 1890, it contained the finest set of nineteenth century townhouses anywhere in New York. In 1898, 50.09 per cent of the local population voted to consolidate with Manhattan and Brooklyn lost its individual identity but, in terms of population, it is still the sixth-largest city in America. The Promenade, in particular, attracts wealthy ex-Manhattanites – happier to gaze onto the city than live in it.

Coney Island is not really an island but a thin strip of land separated from Brooklyn by a small creek. 'Ineffably beautiful is this fiery scintillation' wrote Maxim Gorky about the amusement park that once attracted a million visitors a year. Today's Wonderland is a shadow of its former glitzy self, but the Wonder Wheel still creaks round and the Cyclone still grinds its way over rickety wooden tracks. This is faded glory, indeed, but, hot dog in hand, you can tread the rusting Boardwalk and relish being in the energetic mishmash of life that is New York.

Coney Island Bay (116)
Brooklyn (117)
Big wheel at Coney Island (118)

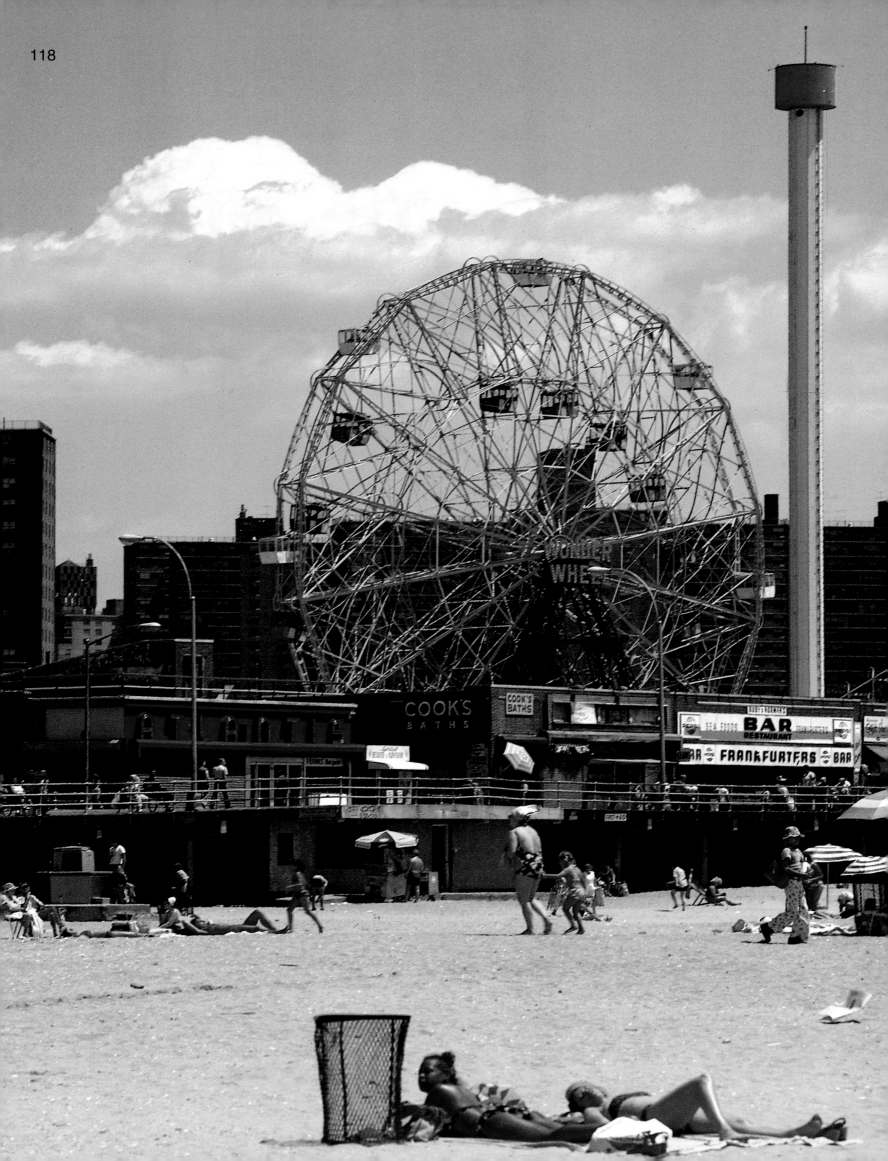

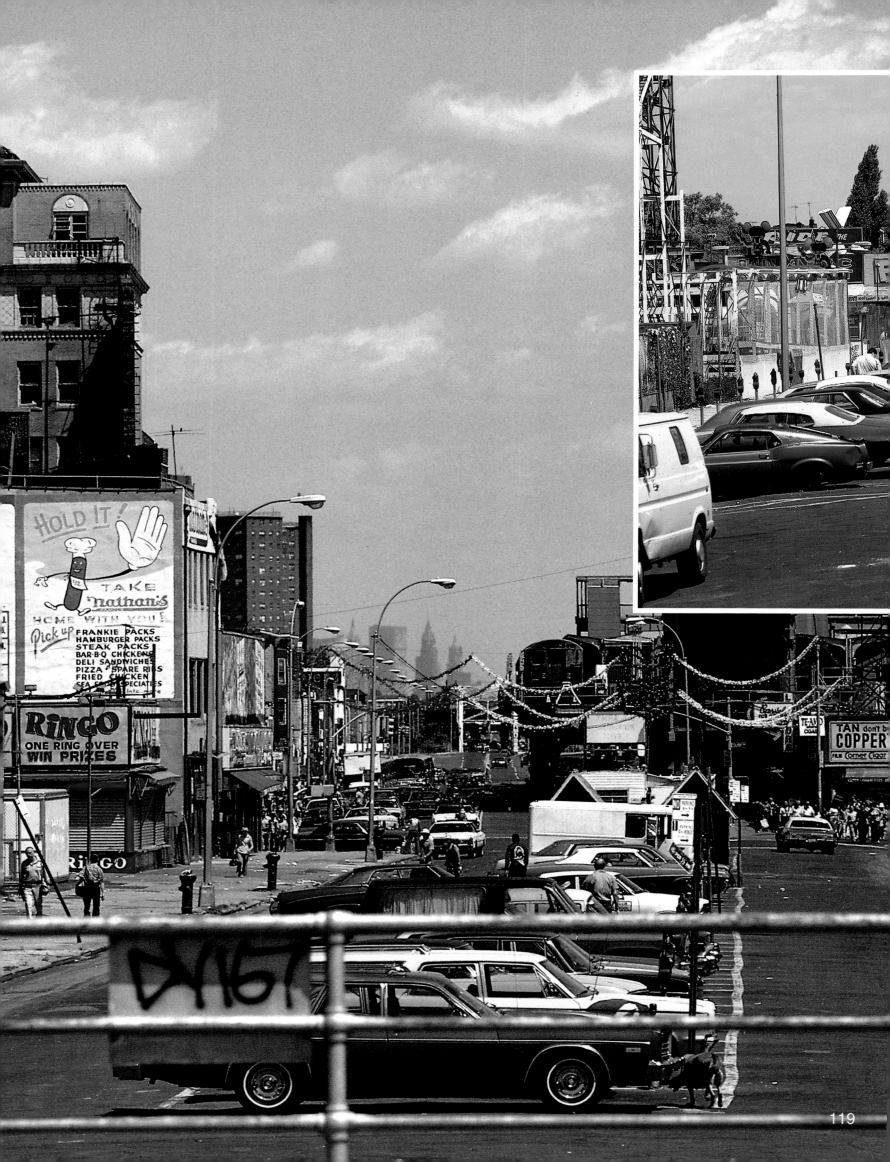

Coney Island (119–121)

Next two pages:
Parade on Fifth Avenue (122–127)

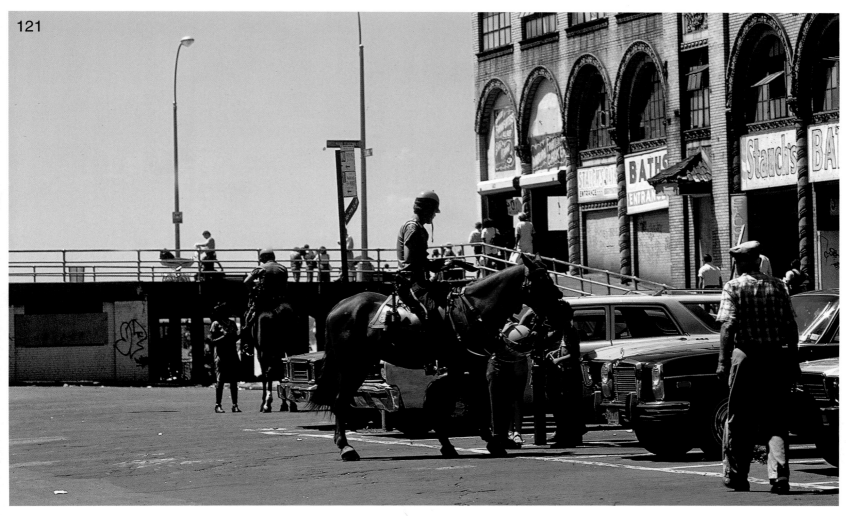

121

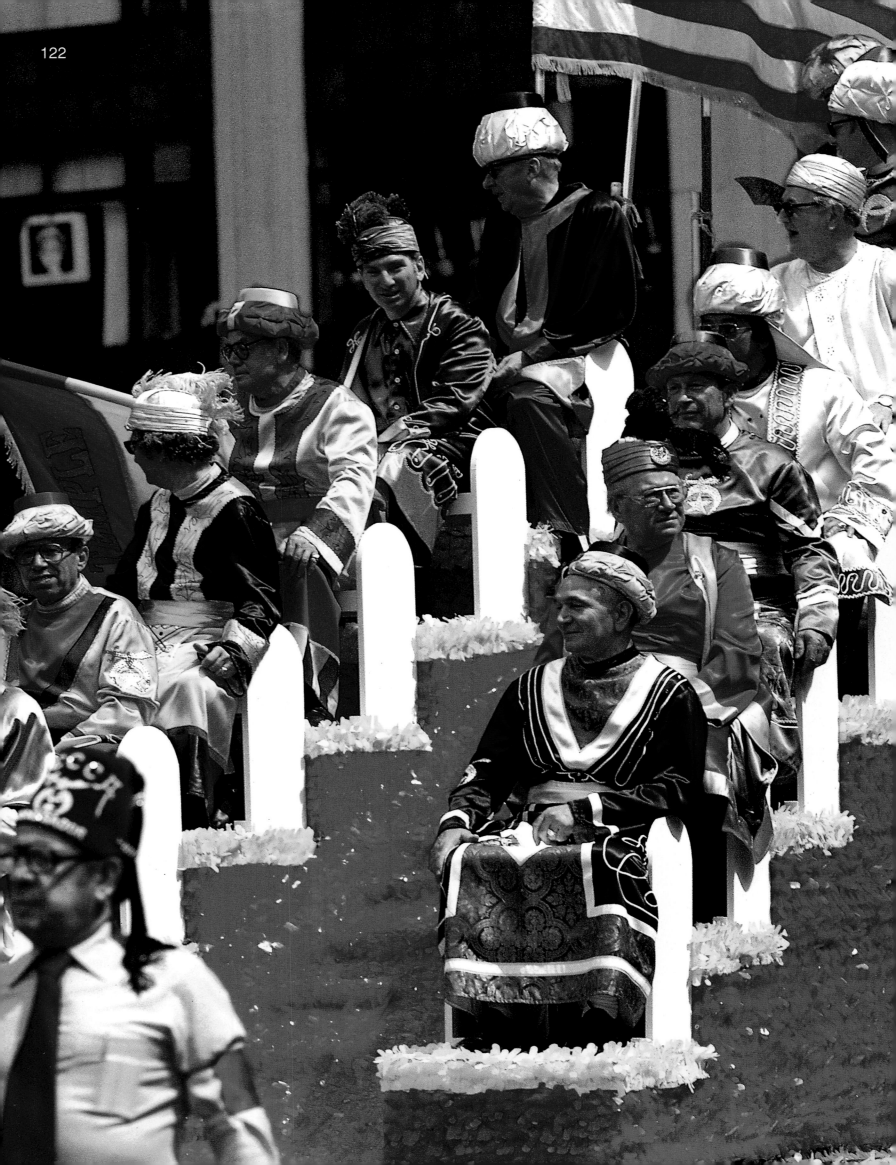

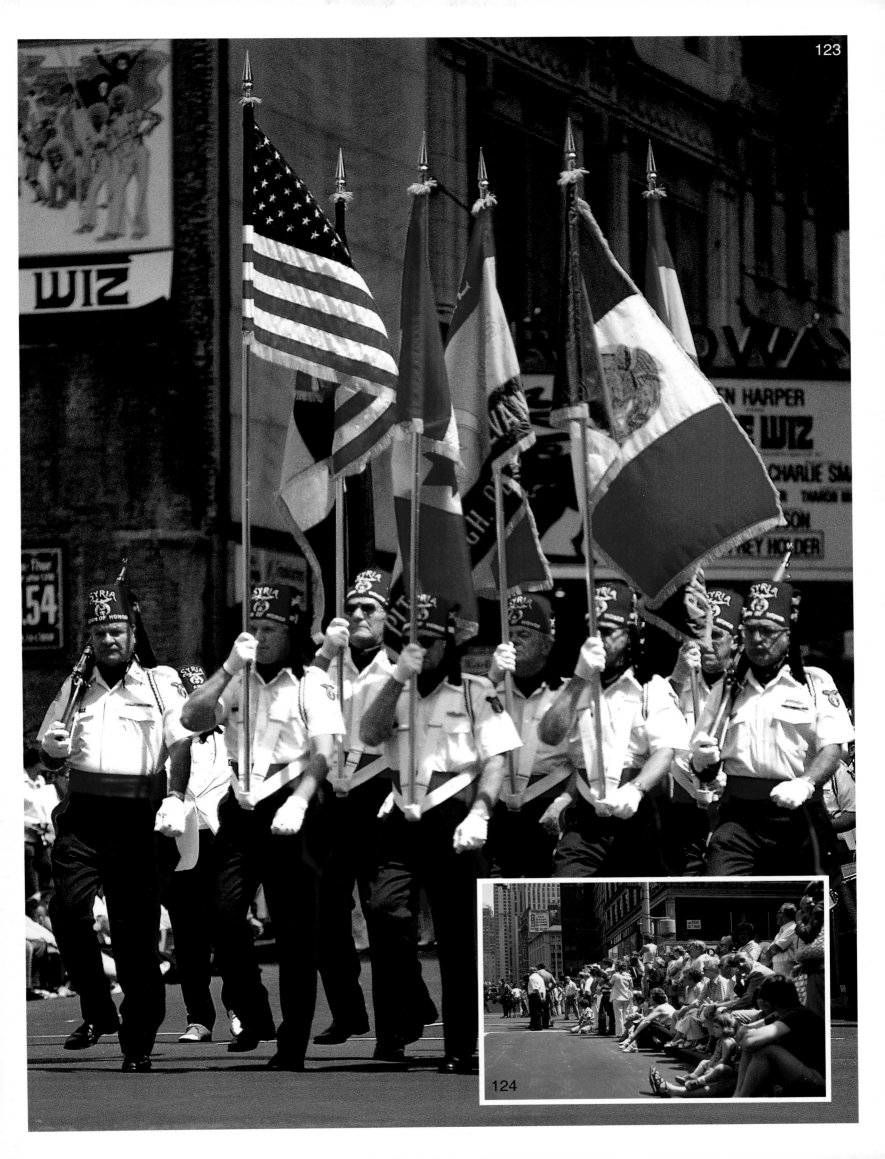

124

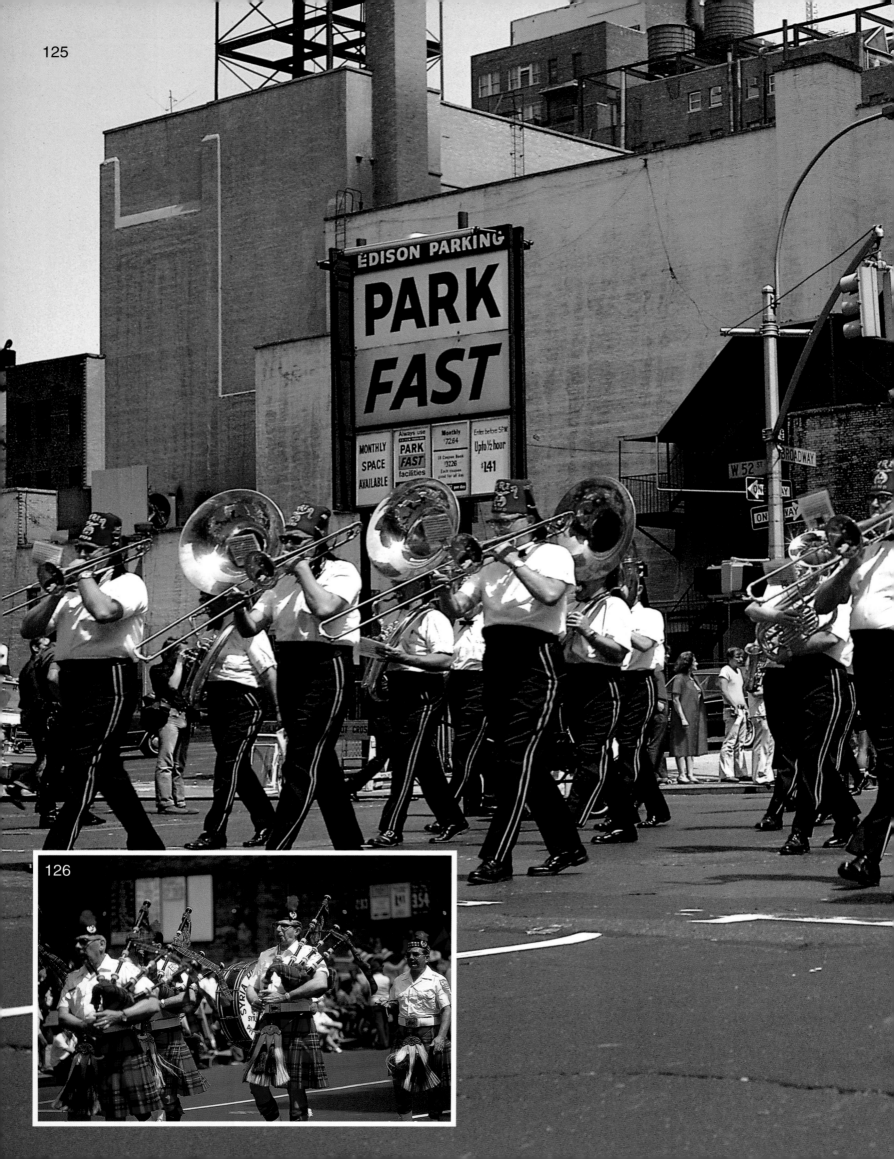

EDISON PARKING

PARK
FAST

MONTHLY
SPACE
AVAILABLE

Always use
PARK
FAST
facilities

Monthly
'72.64

'32.26

Enter before 5PM
Up to ½ hour
$1.41

W 52 ST
BROADWAY
ONE WAY
ONE WAY

126

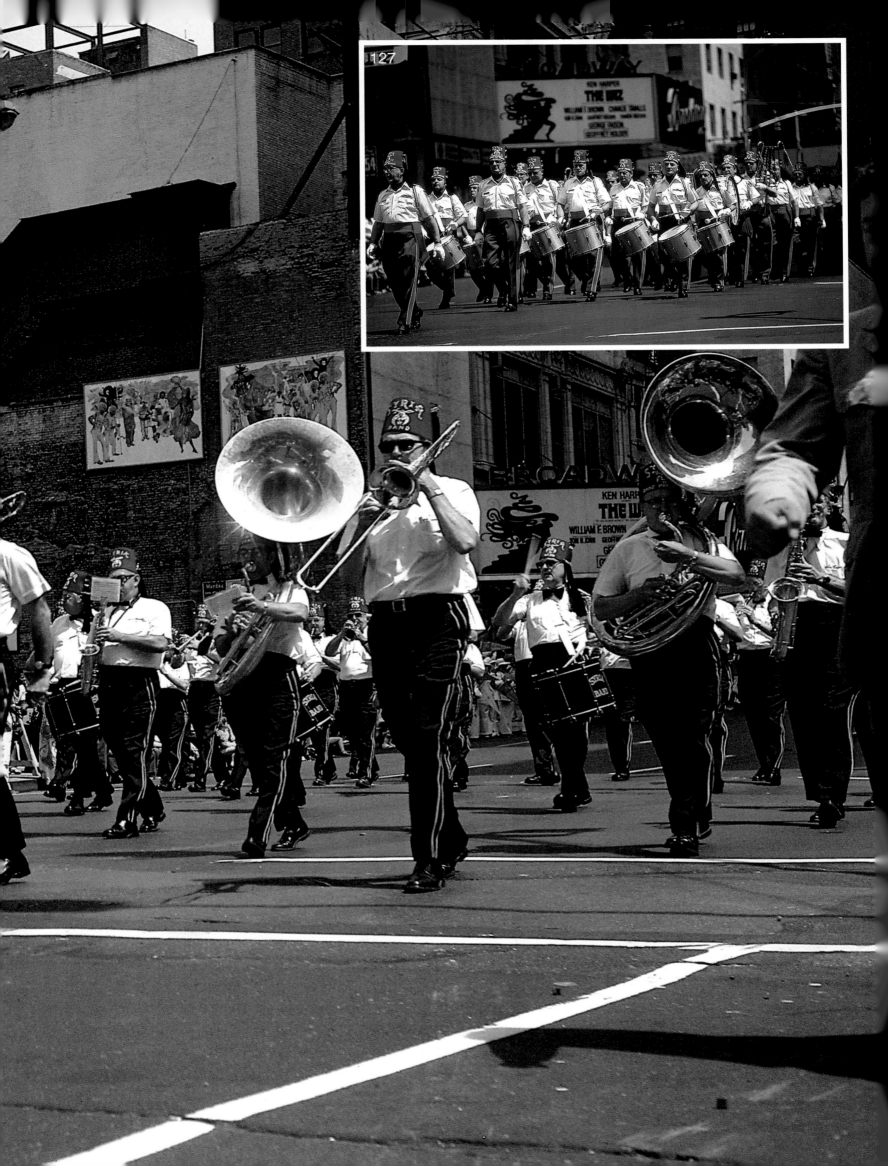

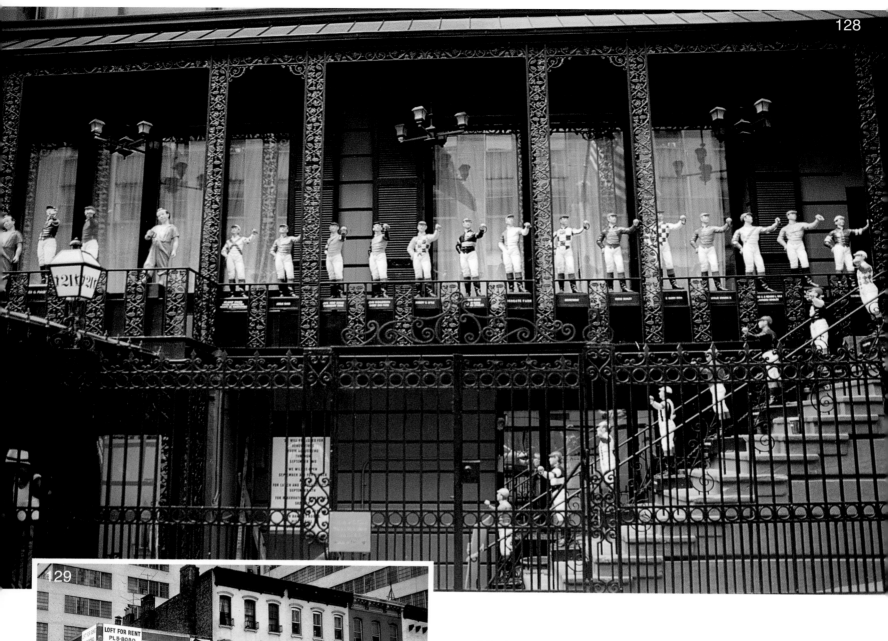

Jockey Club in Manhattan (128)
Manhattan (129)
Facade in Manhattan (130)
Street in Brooklyn (131)

Publishing Director
Jean Paul Manzo

Text
Esther Selsdon

Design and page layout
Parkstone Press
Assistant: Bastien Lelièvre

Photographs
Klaus H. Carl, Andrea Luppi, M. Pucciarelli

Parkstone Press Ltd
Printed and bound in Europe, 1999
ISBN: 1 85995 520 7

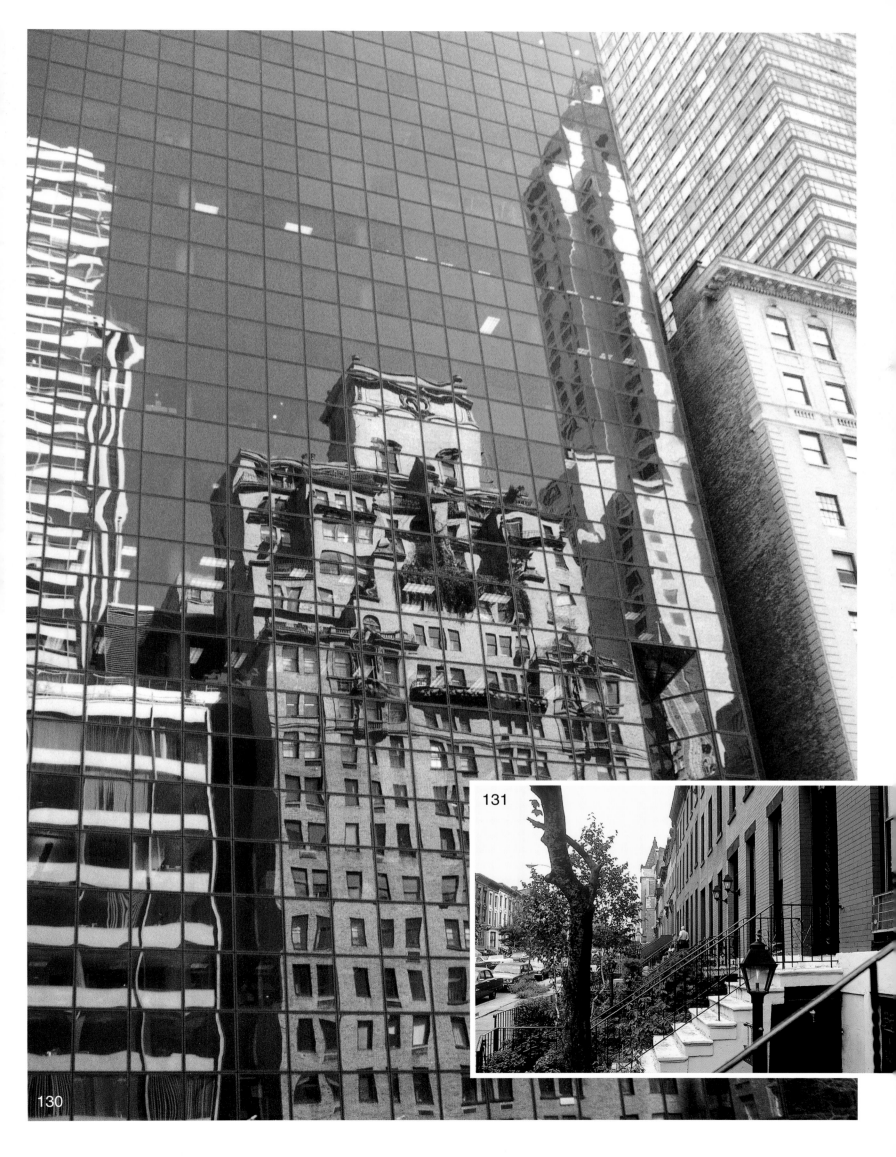

130

131

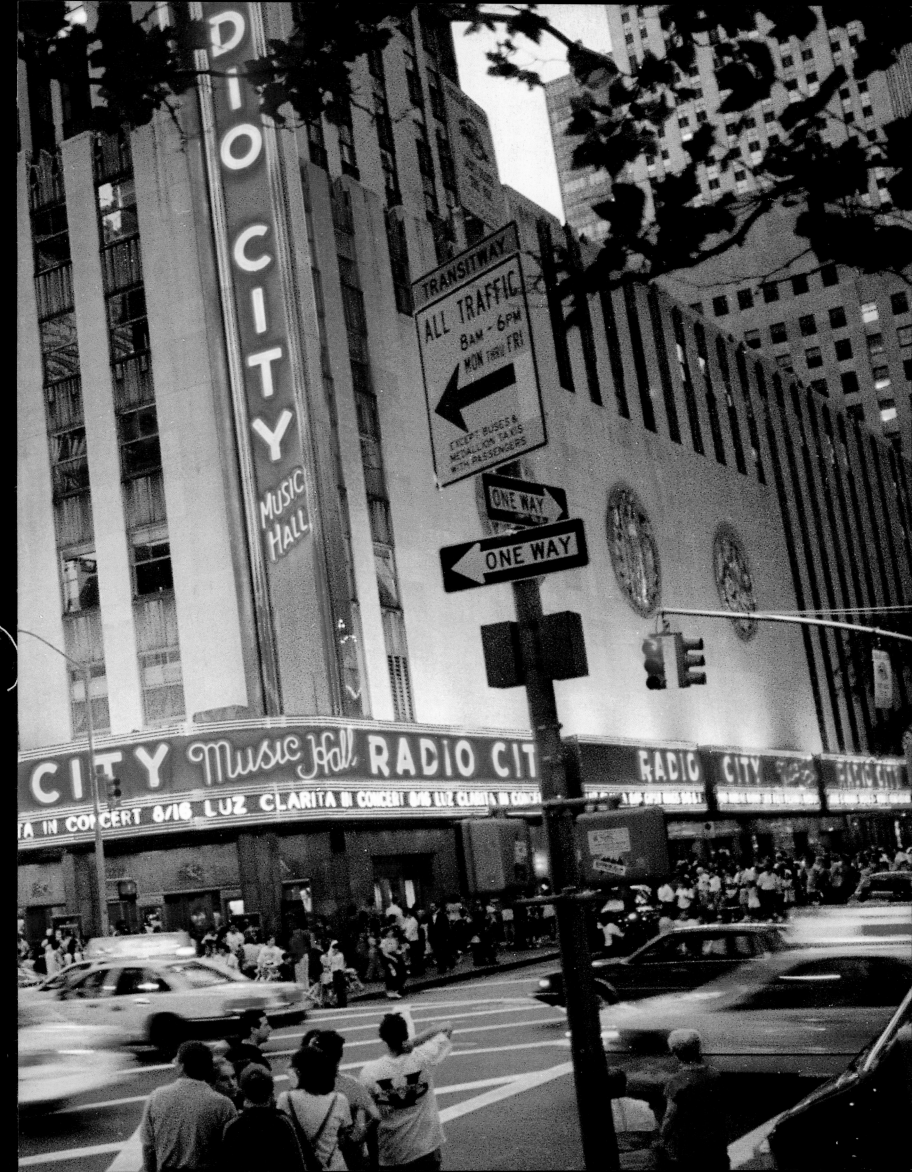

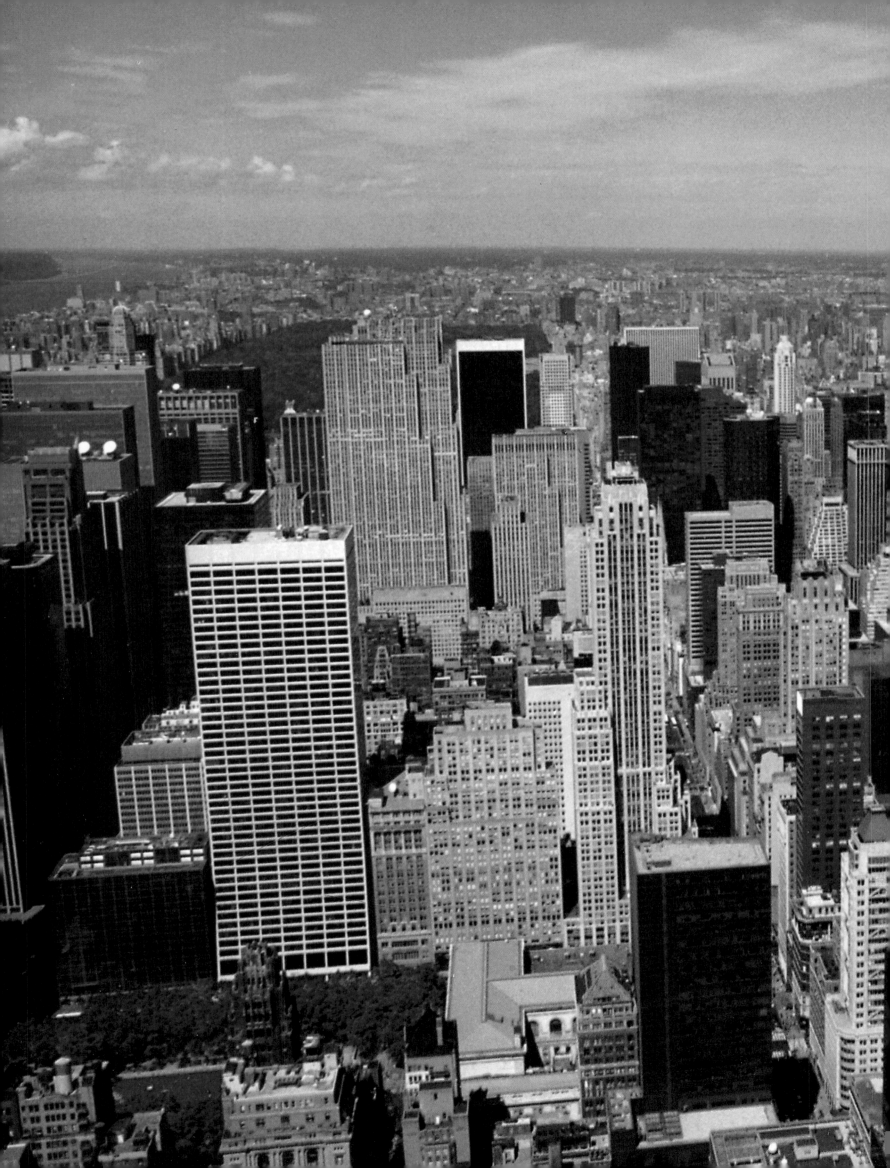